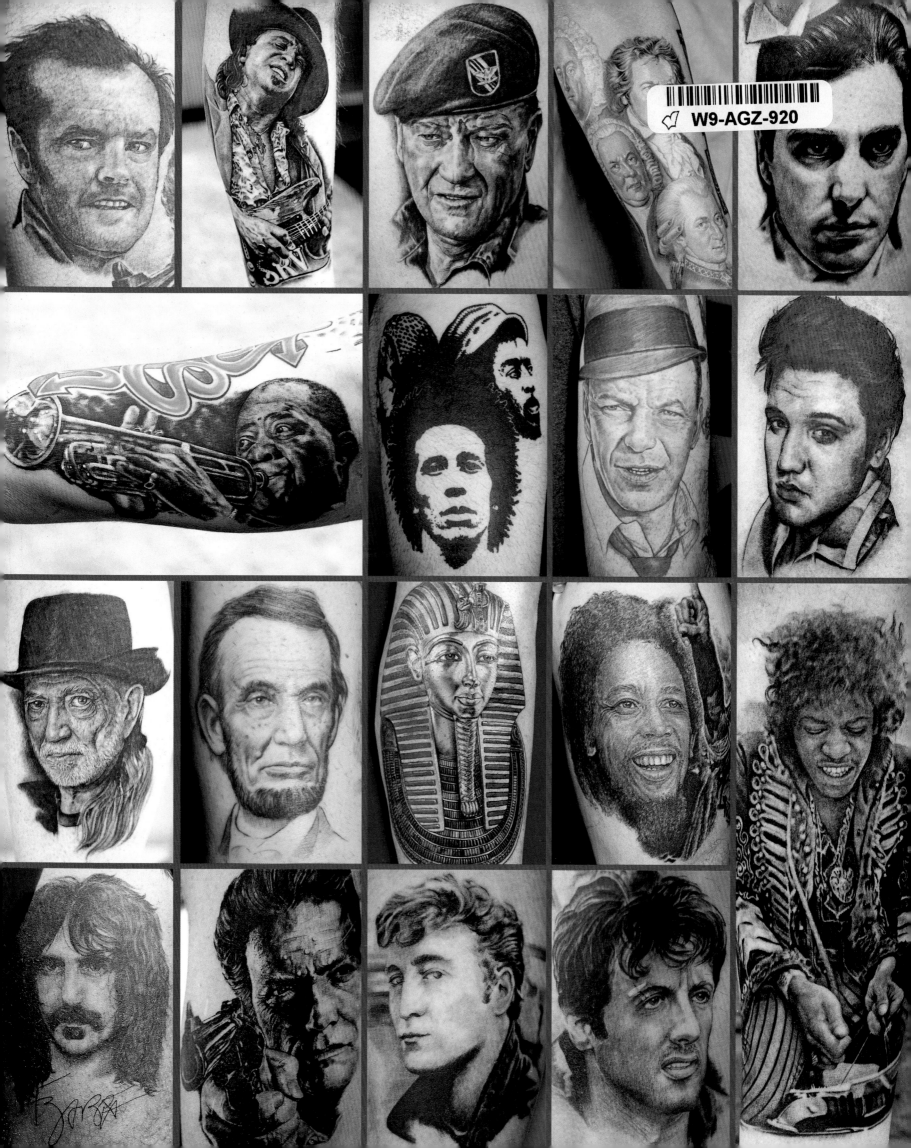

Rolling Stone

Tattoo Nation

Portraits
of Celebrity
Body Art

•• *Introduction by David Ritz* ••

Bulfinch Press
AOL TIME WARNER BOOK GROUP
Boston New York London

Show & Tell
By David Ritz

TATTOOS CUT DEEP. As fantasies, as dreams, as symbolic declarations, they breathe beneath our skin. They augment our private or public lives; hidden or exposed, they come to life as erotically intimate penetrations, signs of self-invention or self-scrutiny, self-denial or self-indulgence, self-love or self-obsession. For many of us engaged in the Western pop culture of the Twenty-First Century, tattoos resonate with musical overtones, imagistic counterpoints to the brashness of rhythm & blues and rock & roll. They scream for attention, cry for affection. They're attempts to fortify the funk, keep the music turned on forever, no pause between songs, no release from the thrill of true grooves liberating us from the tedium of an ordinary look or an ordinary life. Tattoos are the ultimate artistic statements about ourselves, turning bodies into canvases of extreme self-expression. Such statements require a ritual that, in turn, requires pain. The pain is the price we pay for a fresh vision – sometimes clear, sometimes confused – of how we choose to walk through the world.

THIS IS A BOOK OF VISIONS. Clarifying or confusing those visions, tattooed people talk about how, when and why they went for the ink. It's all show-and-tell. The stories are silly, profound, thoughtful and odd. The stories, paired with their correspondent symbols, say all that can be said about why some of us feel compelled to decorate our bodies in a permanent fashion. In explaining the mystique surrounding tattoos, I can only tell my own odd story. In doing so, though, I recognize and respect the mystery of the lure. Mysteries are mysteries precisely because they defy easy resolution. In asking the question – How did I, a fifty-eight-year-old man, wind up with fourteen pieces of modern art marking up my body? – I'm still not sure my answer makes sense.

＊ ＊ ＊ ＊ ＊

IT BEGAN A DOZEN YEARS AGO, when my twin daughters, Alison and Jessica, were in high school. They were leafing through a book of tribal tattoos, all the rage back then, when I glanced over their shoulders and innocently commented, "Maybe one day I'll get a small tattoo."

"Who are you kidding?" they replied. "You're not the type."

I resented the typecasting. I protested, "You might not know me as well as you think you do."

I thought it over for a few days. I envisioned a small symbol – of what I wasn't sure – that might sit discreetly on my right shoulder. I went so far as to visit a tattoo parlor. The place was filled with bikers and gangbangers picking out pictures of ferocious snakes, tigers and bare-breasted women. Thoroughly intimidated, I left without saying a word.

"You're right," I confessed to my daughters. "I'm not the tattoo type."

* * * * *

THE STORY MIGHT have ended there had Alison and Jessica not brought me a newspaper profile of Jill Jordan, described as a fine artist working in tattoos. Formally trained at an art school, Jordan was said to be selective about who and what she tattooed. The writer called her sensitive. "Sounds like your kind of person, Daddy," said the twins. "Maybe you should meet her." By then I had a notion of what would be my one and only tattoo. Wild about rhythm & blues since I was a child, I saw the simple letters *R&B* as a heartfelt tribute to a lifelong passion. Because I write biographies of rhythm & blues artists, it also seemed professionally appropriate. Armed with enough rationalizations to

keep me from feeling entirely foolish, I went to see Jill Jordan in her Hollywood tattoo parlor. The name – Red Devil Tattoos – gave me pause, but Jill was pleasant and to the point. It would take her three weeks to prepare a design. Three weeks later, I saw the design. I liked it but in the secret silence of my head was convinced I was losing my mind and ruining my body. She couldn't actually tattoo me for another three weeks, during which I considered bailing. The night before had me crazy with anxiety. The next morning I felt like I was going to my execution. For reasons still not entirely clear, I went through with it. I sat there and experienced a pain more annoying than excruciating. It took less than a half hour. I was branded "R&B." When the bandage came off twenty-four hours later, I looked in the mirror. I didn't like what I saw; I loved it.

I'm embarrassed to say I was giddy with the pleasure of the thing. It seemed quite perfect; it seemed to be me. I was set. A middle-aged man with a small tattoo on his right shoulder, nothing more, nothing less. But soon my satisfaction was unsettled by a simple notion: I had two shoulders, not just one; moreover, I had two musical passions – R&B and jazz. Jazz, after all, was my first love. With "R&B" sitting so sweetly on one shoulder, wouldn't "Jazz" be the perfect complement for the other? Within a month I was back at Jill Jordan's. I went through the

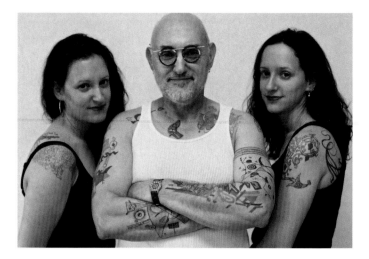

Flesh and blood: David Ritz with daughters Alison (left) and Jessica

same process, gaining respect for Jill's deliberate and artful approach. The jazz design, like its R&B sister, was vibrant; it seemed to sing. The second tattoo delighted me even more than the first. I was balanced between the two musical strains that sustained my heart. I needed nothing more. Or did I?

I did, but I didn't know it at the time. I thought I could get away with this modest duo of tattoos, but my mind wouldn't rest. I began considering other designs on other body parts. The jones kicked in. Then came the epiphany: I was seated in Town Hall in New York City, listening to pianist George Shearing perform "Celia," a breathtakingly beautiful ballad by bebopper Bud Powell. Onstage behind Shearing was a large canvas by Stuart Davis, an American who depicted jazz as cubist expressionism. Shearing's gentle lyricism seemed to conspire

with the poetry of the painting. I found myself crying. I'm not sure why – perhaps because the song suggested the mystery of the Forties, the decade of my birth and my parents' troubled romance, an epoch I've always viewed with aching poignancy. I felt consumed by beauty.

The next day I went to the Metropolitan Museum of Art, where a major Stuart Davis exhibition was on display. I bought the book from the show, studied it for weeks and finally found myself at Jill Jordan's studio asking whether she could translate Davis into a tattoo. She thought she could. But when I saw the sketch weeks later, I was astounded by its size. It was enormous, starting at my shoulder and spilling down to my elbow. "Can't it be smaller?" But I knew the answer before the question left my mouth. The design demanded length and breadth. This kind of art, like jazz, required room to breathe.

A month later, I watched myself watching the tattoo take form on my arm. This was a different sort of commitment. This tattoo was hardly discreet; it was screaming. A voice inside my head was screaming that this time I had really done it, ruined whatever sense of decorum I had once possessed. But when the deed was done, when I looked at Jill's extraordinary design, a louder voice exclaimed, "Fuck decorum; this is funky!" Suddenly all bets were off. I saw what my unconscious had certainly seen long before I was will-

ing to admit it: I was a work in progress.

My warped sense of symmetry led to another Stuart Davis–inspired tattoo on my lower left arm; a sprawling Kandinsky would soon dance across my lower right arm. The larger the tattoos, the bolder Jill's designs, the more confidence I had in her ability to understand the images I wanted under my skin. Not only was her craftsmanship a fine mixture of skill and soul; the colors of her ink – hand-selected from countries around the world – were so startling that many people scrutinizing the tattoos were certain they'd been painted in oils.

In six-month or eight-month intervals, the tattoos multiplied. Fragments from various Miró paintings were pieced together and drawn on my upper right chest. My love for 1950s coffee-shop decor was satisfied by a sprawling wallpaper design from that period. I borrowed from lesser-known artists like Steve Wheeler, whose bursts of mechanical imagery excited my whimsy and now adorn my clavicle and right leg. A dripping Jackson Pollock was recently inked on my left calf.

* * * * *

I AM, IN SHORT, an illustrated man. My tattoos give me visceral pleasure, much of which comes in the form of the reactions of others. To the perpetual question – What is it? – I offer a perpetual answer: Art. I'm gratified that for the overwhelming majority of observers my tattoos bring smiles and warm greetings. An astounding number of strangers look at them and simply say, "It's all about music, isn't it?" It is.

My daughters, who led me to Jill Jordan, went to her a little while after I did and were tattooed in distinctive ways that bear no relation to mine. It was my wife, Roberta, initially skeptical of my tattoo obsession, who offered the most telling analysis of all: "They represent a triumph over your troubled childhood," she said. "They're your way of asserting your happiness."

I do believe happiness is the key, the kind of happiness that comes with embracing a mystique I can never quite grasp. When, for example, others ask, "How do you know that you want that stuff on you forever?" my answer is, "I don't know." Not knowing is part of the fun. I love the notion of permanent whimsy when, in a flash, I see a colorful image and decide to make it part of me. The more tattoos I have, the less seriously I take them. I see them as flights of fancy blessing me with the same sensations I experienced listening to George Shearing playing "Celia" – a rush of spontaneous beauty, a feeling of fleeting joy.

* * * * *

DAVID RITZ, *a four-time winner of the Ralph J. Gleason Music Book of the Year Award, recently completed a biography of jazz singer Jimmy Scott (Da Capo Press).*

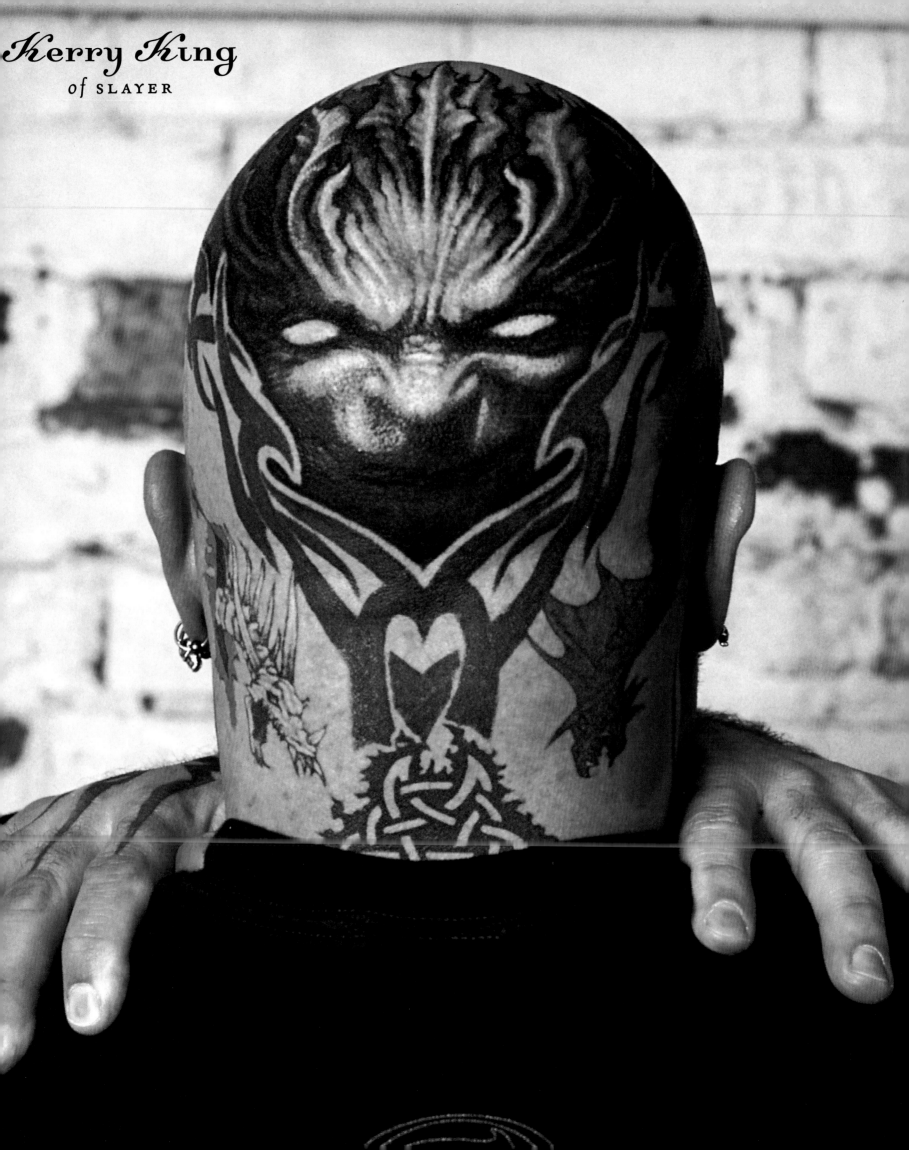

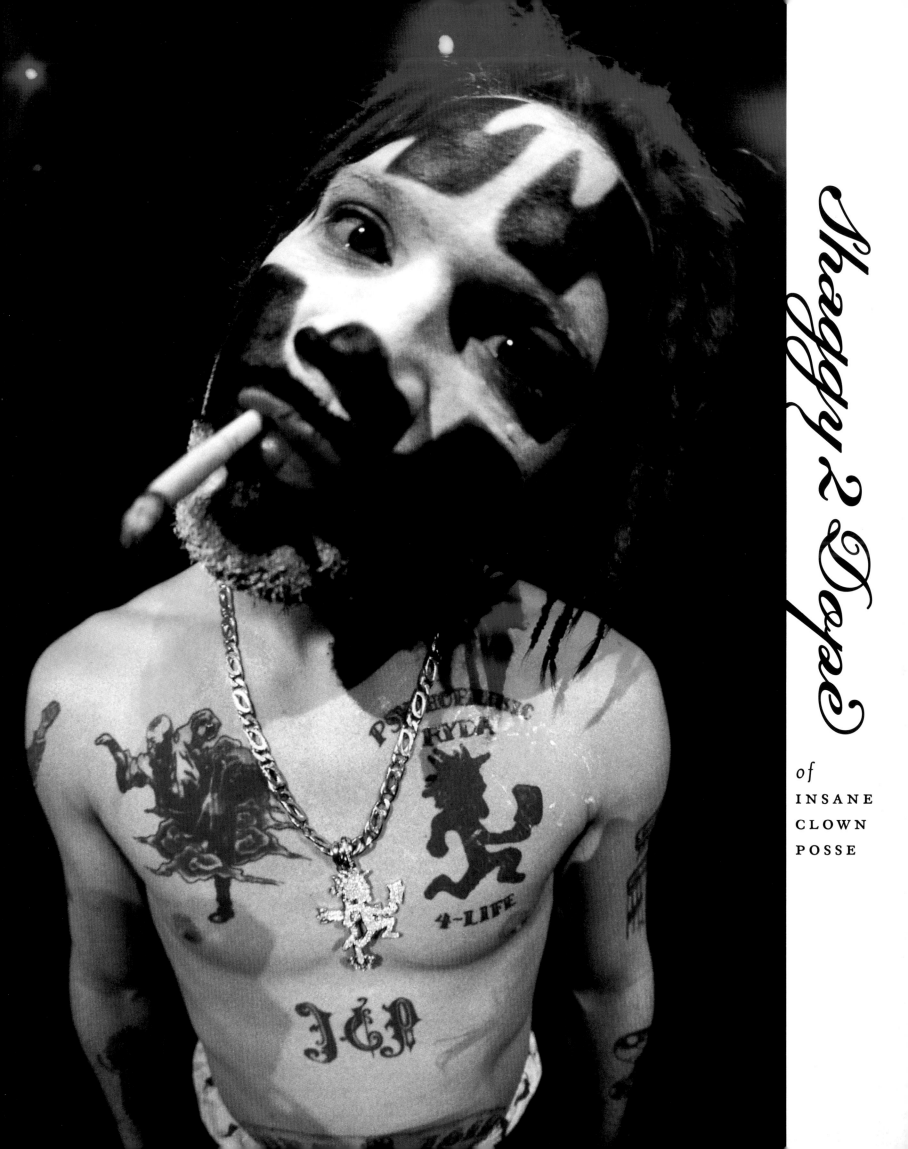

Shaggy 2 Dope

of INSANE CLOWN POSSE

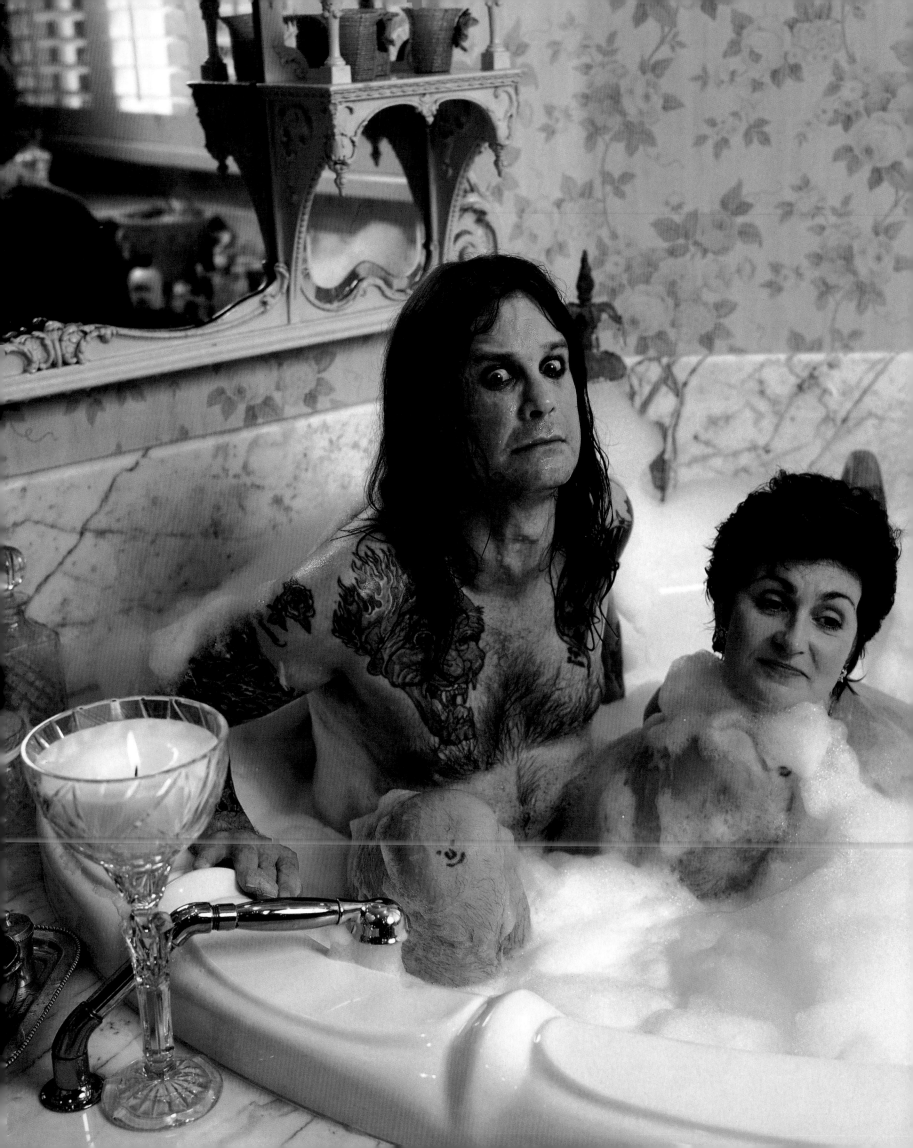

Ozzy Osbourne

How did it start?
I was about fourteen when I got my first tattoo. It was a knife on my left arm.

Didn't you do the first ones yourself?
Yeah, I did a bunch. I had a guy in prison do the other. I did "Ozzy" on my knuckles myself. I can't remember when, years ago.

And the smiley faces on your knees, you did those, too?
Yeah, yeah. I was just doodling one day, and I just did it. Then I had that big dragon done on the right side of my chest, and I had the Grim Reaper done and I had the back of my shoulder and then these drunk fools . . . we went to the tattoo parlor and I got these fucking revolting groupie tattoos on my shoulder.

Anything else on that arm?
Yeah. I covered an old tattoo on my arm that was damaged when I fell through a window one time. The dragon I have on my chest is my favorite.

Did you come up with that yourself?
Yeah, yeah. I was looking through a magazine at the tattoo parlor, and this was in Japan – they have this boogeyman over there that comes in the night and steals your babies. I thought the colors looked really cool.

The other side of your chest?
The Grim Reaper. Early Eighties.

The rose on your other shoulder?
Yeah, for some reason, I always wanted a rose tattooed on my arm, I don't know why. And I've got "Sharon," my wife's name, underneath that. It looks pretty cool, pretty eloquent. But if you want some advice from me, don't have a tattoo at all. 'Cause everyone's got a tattoo now. If you want to be someone special, don't have your face pierced either. It's not so much the rock guys who are going to look fucking horrendous in twenty or thirty years' time, it's the chicks. If you want to make some money, invest in the laser removal thing. Before you get a tattoo, you've got to say to yourself, "Am I prepared to look at these things for the rest of my life?" I remember one day in L.A., I was with my stepson, and there was a line of chicks crossing the road and it was like watching a fucking bunch of pirates. They didn't have bluebirds on their shoulders; they had, like, battle scenes on their backs. If you really want a tattoo, you should discuss it with your parents and say, "Do you think it would look okay if I had this fucking dragon tattooed on my back?" Talk to someone about it. Or get the tattoo artist to draw the tattoo and walk around with it for a few days.

Were you drunk for every one?
Some, some not. When I got the big green dragon I was stoned.

You were out of it for the groupies and the bat?
Yeah.

The biomechanical thing?
I was straight, stone-cold sober. I wish that I had been fucking stoned.

If you don't like it, why did you do it?
My son was into these alien movies, so to make him happy I got it. Then he went off the films, and I'm stuck with it.

You must love him.
I do love him. I adore him.

You've got the word 'thanks' on your palm?
Yeah. You know, you put your hand out, thanks . . .

Does your wife have tattoos?
No, no. My daughter just came up with a little heart tattoo.

Would you be angry at your kids if they got the whole sleeve tattooed?
I would fucking hit the roof.

Ozzy and wife, Sharon Osbourne

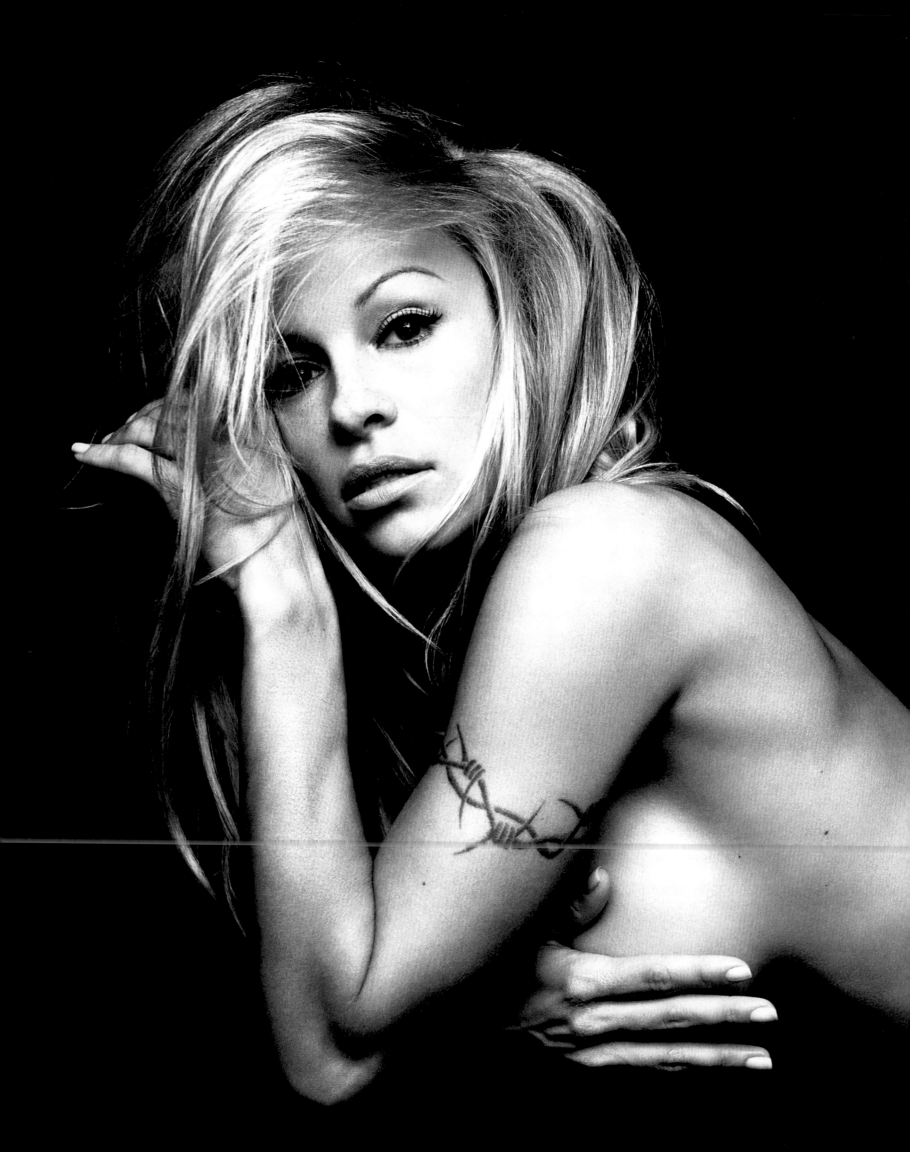

Tattoos are symbolic of the important moments in your life. Talking about where you got each tattoo and what it symbolizes is really beautiful.

—Pamela Anderson

Busta Rhymes

THE REASON I love tribal tattoos is that they don't stigma you to any particular time frame. You might get a Porky Pig tattoo on your chest, then twenty years from now Porky Pig ain't the style of tattoo to get, you know what I'm saying? On my forearms I got two Oriental tatts. One says "Health and Happiness" and the other says "Long Life." I wish that on myself. I'm trying to be here for the long haul, man. I'm only going to put tattoos on my body that have personal value and significance, and those two were something that I valued personally. Even way before I was allowed to get tatts.

* * * * *

I GOT MY FIRST TATTOO when I was about twenty-two. The tattoo is of my sons' names, Tahiem and T'ziah. I just loved them so much, and I knew that they were going to be what I live for and what I represent. And I would never regret having their names branded on my body forever.

* * * * *

ON MY LEFT SHOULDER I have the Flipmode logo. I definitely got to put the company logo there, because even before it was a company it was the clique that I rolled with. And that I still roll with. And when it's all said and done, this is the clique that we established and built to help secure the well-being of our own lives and our families' lives. If I'm loyal enough to have something put on my body that I can represent comfortably for life, then that means my loyalty is long term. At least that's what I try to represent through tattoos – not only that, but through my actions, my relationships. You know, I'm a loyal cat. I live by that commitment.

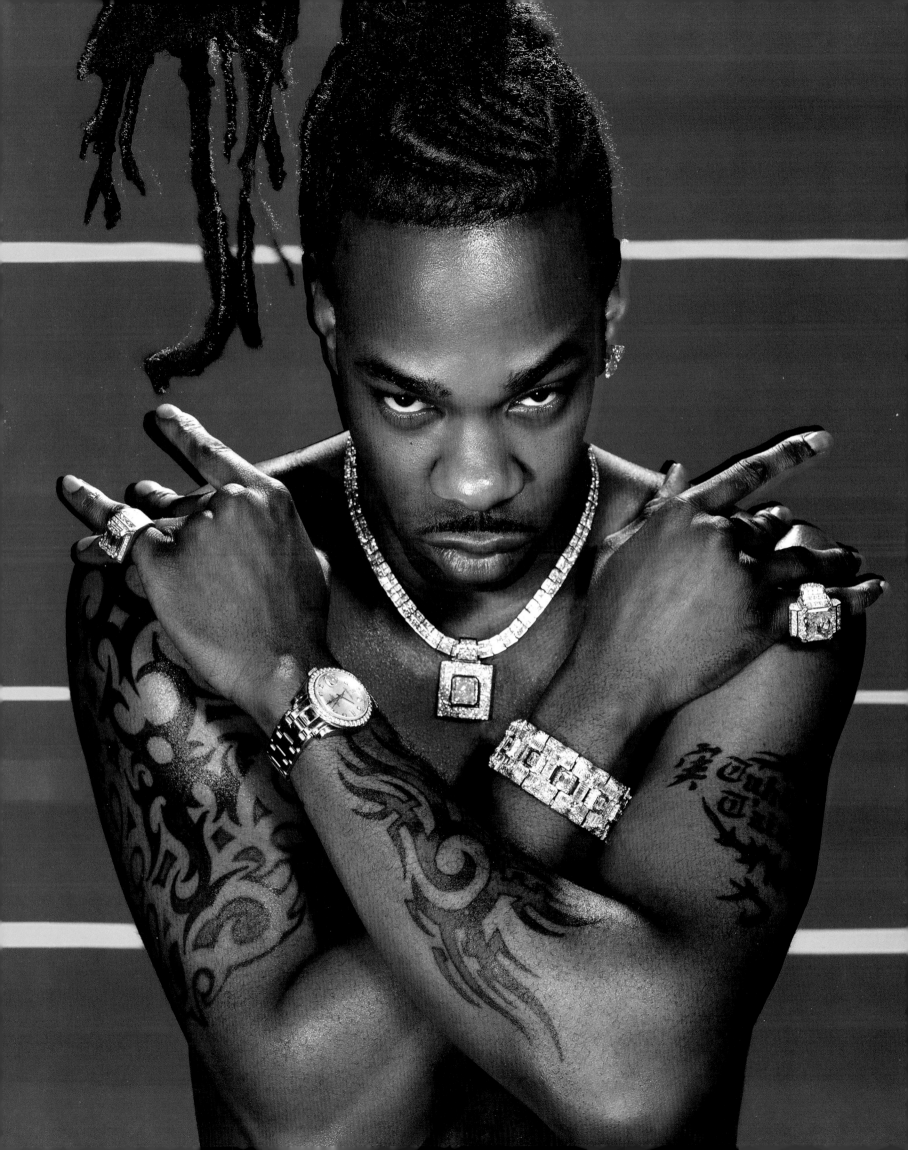

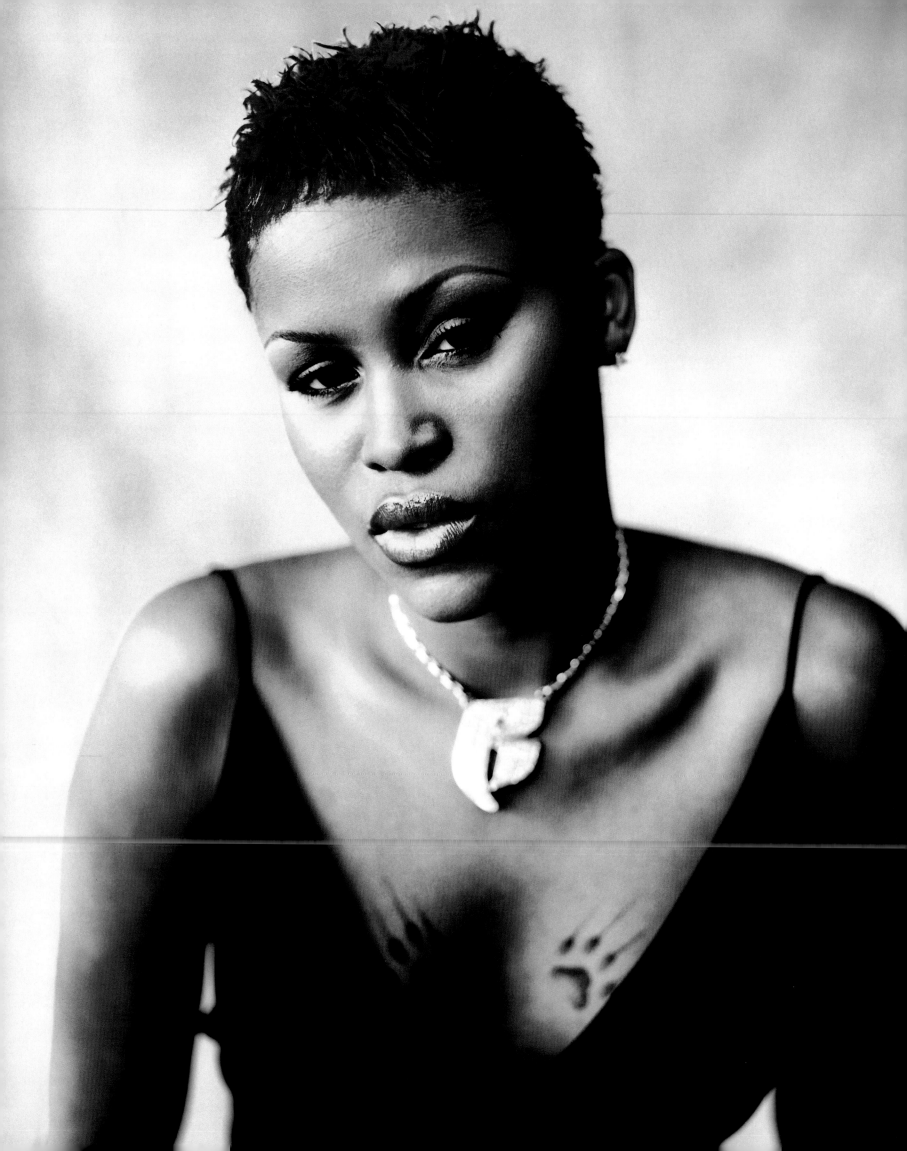

Eve

When did you get your first tattoo?
I got it when I was seventeen, on my right shoulder. I just wanted a tattoo. Boredom. I always do things because I'm bored. And my mom is always like, "Do it, but don't complain." It's just a small one – I wanted to get the four seasons, but I couldn't take the pain, so I only got winter. And now that's covered up with a flower, because I hated the way it looked. They were going to do a whole design with a circle around it, but I just couldn't take it.

So why did you keep going?
I don't know. I just wanted more. It hurts. A lot. I really don't know why I put myself through the pain. I just love the way they look.

What was your second one?
It's on my left shoulder, and it's a Chinese symbol for evil and a little "Eve" underneath. I just wanted a tattoo, so I went to the place and sat down and picked it out. Then I got paws on my chest. I saw it on

someone else, but I didn't want it quite the same. I wanted to do something different, and I kind of collaborated with the artist on that one. We went through a couple different designs.

Are your tattoos more than just designs?
Oh, definitely. I got one on my lower back after I got the paws, and after I had finished my first album, a scorpion and two Chinese symbols that mean "strong woman." That was important to me because I didn't think I'd be able to finish an entire album by myself. And then I covered up the winter tattoo on my shoulder with a flower, just because I love flowers now, and I wanted to get another tattoo after I had finished my second album. I also have a flower on my wrist, also a cover-up. I used to have my ex-boyfriend's name there.

And at the time you thought that was a good idea?
He was my first love. I think that's the ultimate. It's like, "Yeah, I'll tell you that I

love you, but let me show you how much I love you. Let me put your name on my body." And then we broke. But I don't care: It was a learning experience. I was young, and I'm still young. Who cares?

How long after you broke up did you wait before you had the tattoo covered?
Well, I was kind of hoping we'd get back together, so it was probably, like, five or six months before I had it covered. All my friends were like, "It's about time. Come on, girl, I'll pay for it."

Do you have plans to get other ones?
I want to. I should stop. But I want to get little ones. I was thinking about a little heart on the back of my neck. Everybody's like, "Just stop. You don't have anywhere else to put anything." But I do. I have more skin.

What's the weirdest place you have a tattoo?
Mine are pretty conservative, really. But I don't know – we'll see what happens.

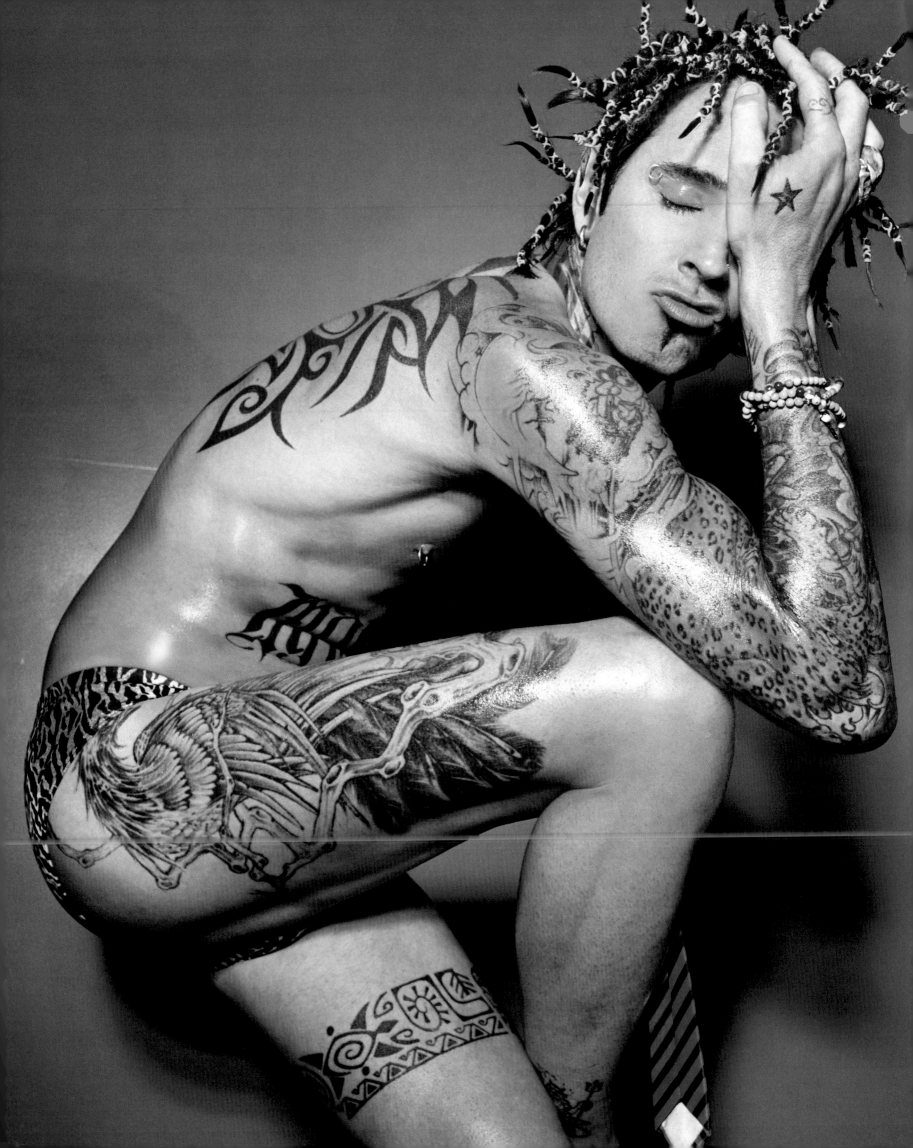

My newest tattoo goes from below my belly button right down to the pubic hair. It's the om sign. Right below it is the lotus flower. I read a lot of literature on Buddhism and Hinduism in jail. I read a lot of books in jail, like forty.

—Tommy Lee

of METHODS OF MAYHEM

TRAVIS BARKER: I've had the ghetto blaster for four years now. I got it because I used to be this little kid who would break-dance on street corners, and I'd have a different ghetto blaster for every day of the week. No, I will never regret getting it tattooed; it has to do with the music I grew up with – it's part of that weird time – so I'm always going to like it.

I don't know why people get tattoos. For me, I have memories with them. In loving memory of people who have passed away – I have one for my mother. I was sixteen when she died. It says "In Loving Memory of Gloria." It's totally a good reminder.

My first tattoo is the one on my right forearm.

Is it there so you can always see it?
Yeah. It's a Virgin Mary.

The ultimate mother-figure thing?
Yeah.

Do you want to get any more tattoos?
Yeah, I'm actually gonna finish my ghetto blaster.

Oh, it's not finished?
Well, it could be if I wanted it to be. But it's all just black and gray. I want to add color, like chrome and stuff where it was silver, you know?

Does it ever hurt?
Yeah, your stomach hurts. Your stomach is probably the worst place – it's the worst place I've ever felt. Your stomach is a totally different kind of pain than anywhere else. Anywhere else, it doesn't really hurt. I'm not, like, the biggest tough guy. I'm not gonna say, like, nothing hurts, but it actually hurts a very tiny bit on your arm or your leg or something. When it comes to your stomach, all of your nerve endings are there. I was squirming around like a little girl. All my friends were like, "Oh, my God," but I still didn't say "ow" or anything. Everyone was freaking out, worried, you know, and I felt like crying.

Why get tattoos?
You live one time. Why not – I don't know, why not? Why not have your whole body tattooed, you know? That's how I feel. It's like decorating your body. You're documenting parts of your life onto your body so they can't be threatened or forgotten. You know, the times when you were a dork and then the times that you were superhappy and you had everything that you ever wanted.

Left to right: Mark Hoppus, Travis Barker, Tom Delonge

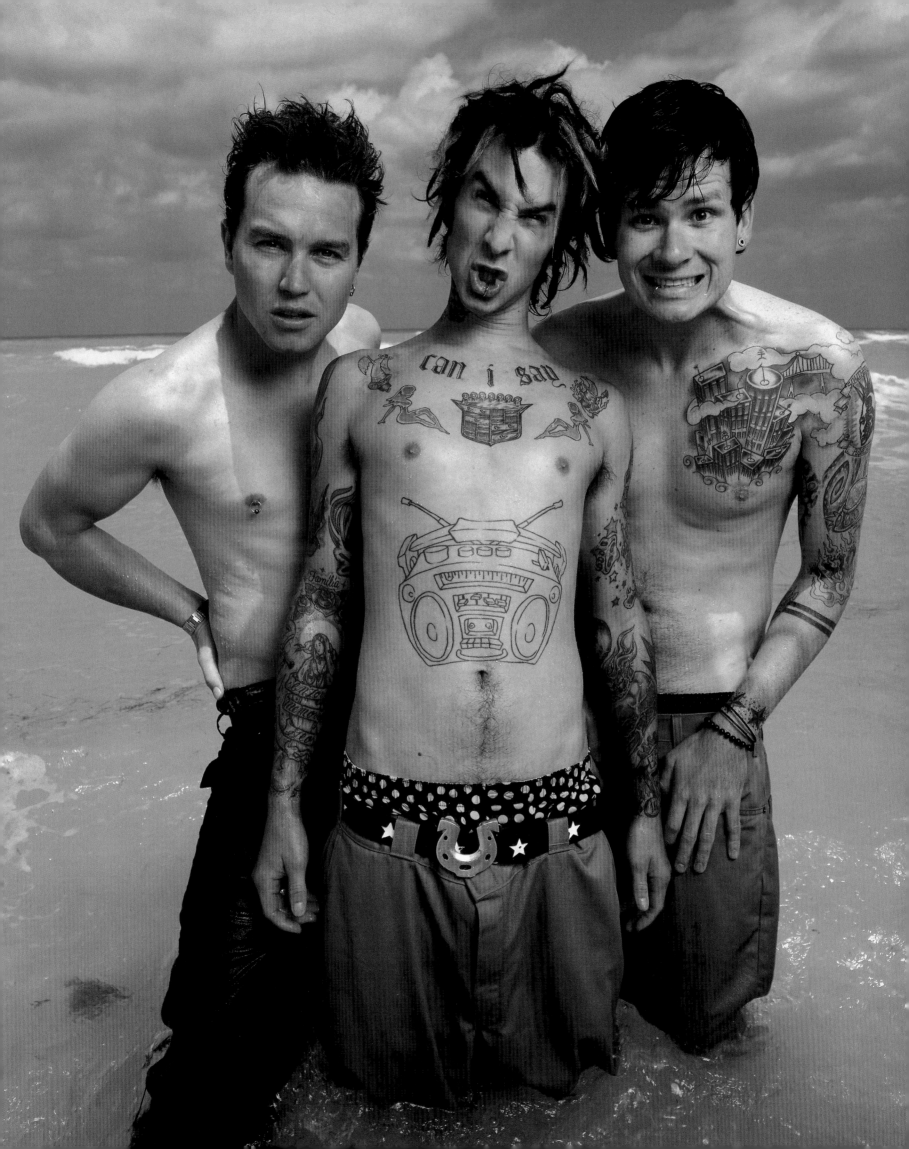

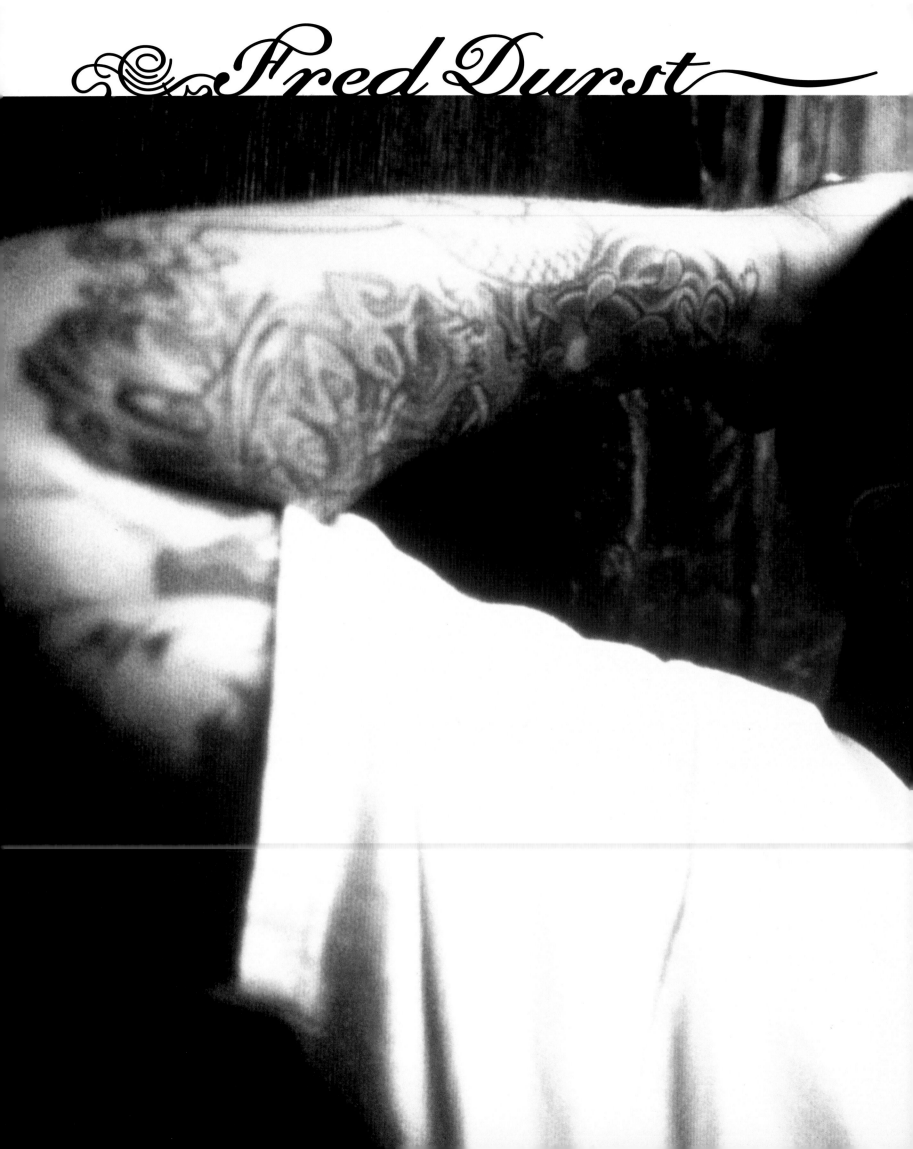

I HATE when girls come up to me, start twisting my arm around and are like, "Lemme see your tatts!" I'm like, "Well, lemme see your tits." I'm not your art exhibit. I'll show them to you if I feel like it.

I got started in tattooing when I moved into my friend's trailer. I bought a kit and self-taught. The first guy I did was a friend who let me practice on him. I didn't know you couldn't go back over the same line. So now it's permanently raised. You're not supposed to be able to feel it in the slightest. Yeah, I've done a lot that sucked. Eventually I started getting better, and through the barter system I'd do a tattoo for a mattress or a refrigerator. Then people started to pay me – that felt so good.

I was fucked-up when I got it. I got drunk and shit, and I was thinking about it, feeling all emotional. Because you always say you'll think about somebody every day after they die. And you know, that fades away sometimes. But now I do, I really do. I'm glad I got it, to this day.

—KID ROCK

ON WHY HIS LATE COUSIN PAUL'S NAME IS TATTOOED ON HIS ARM

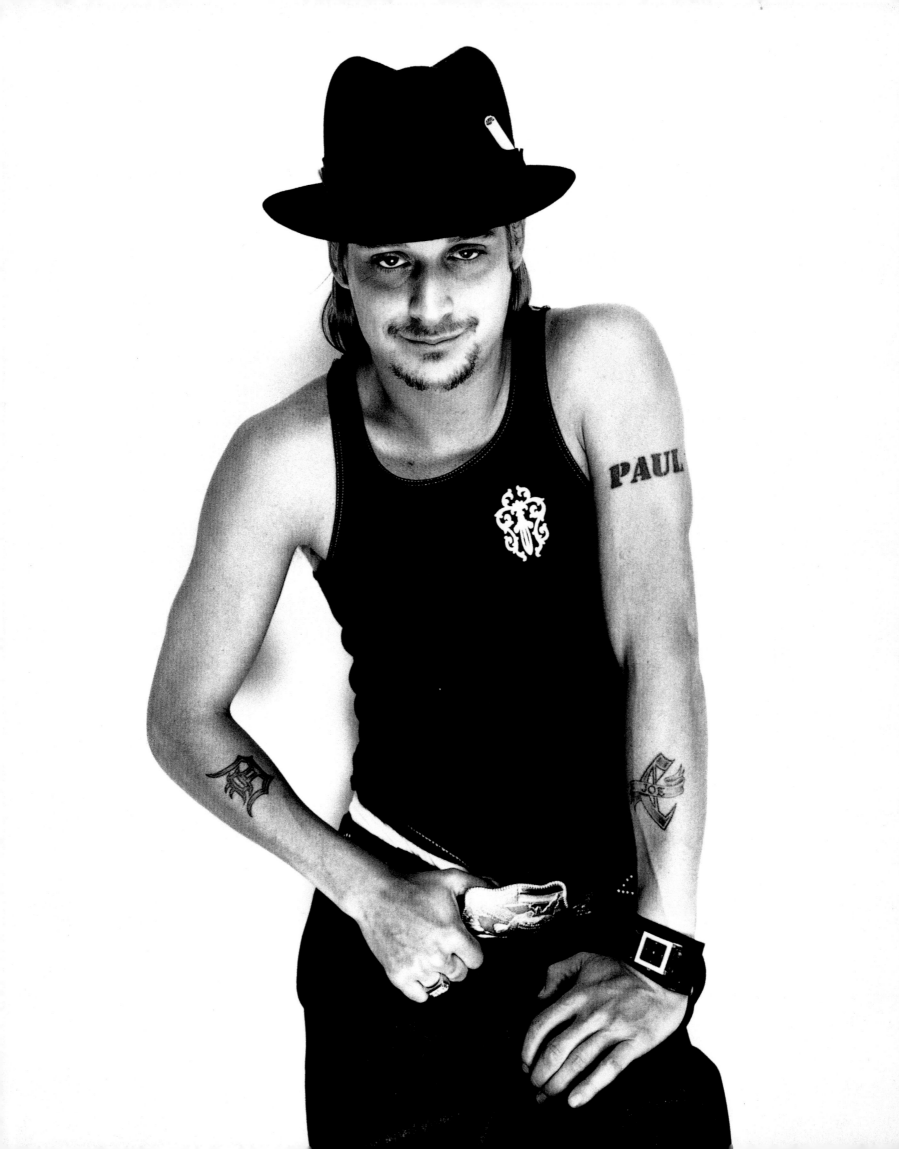

Treach

of NAUGHTY BY NATURE

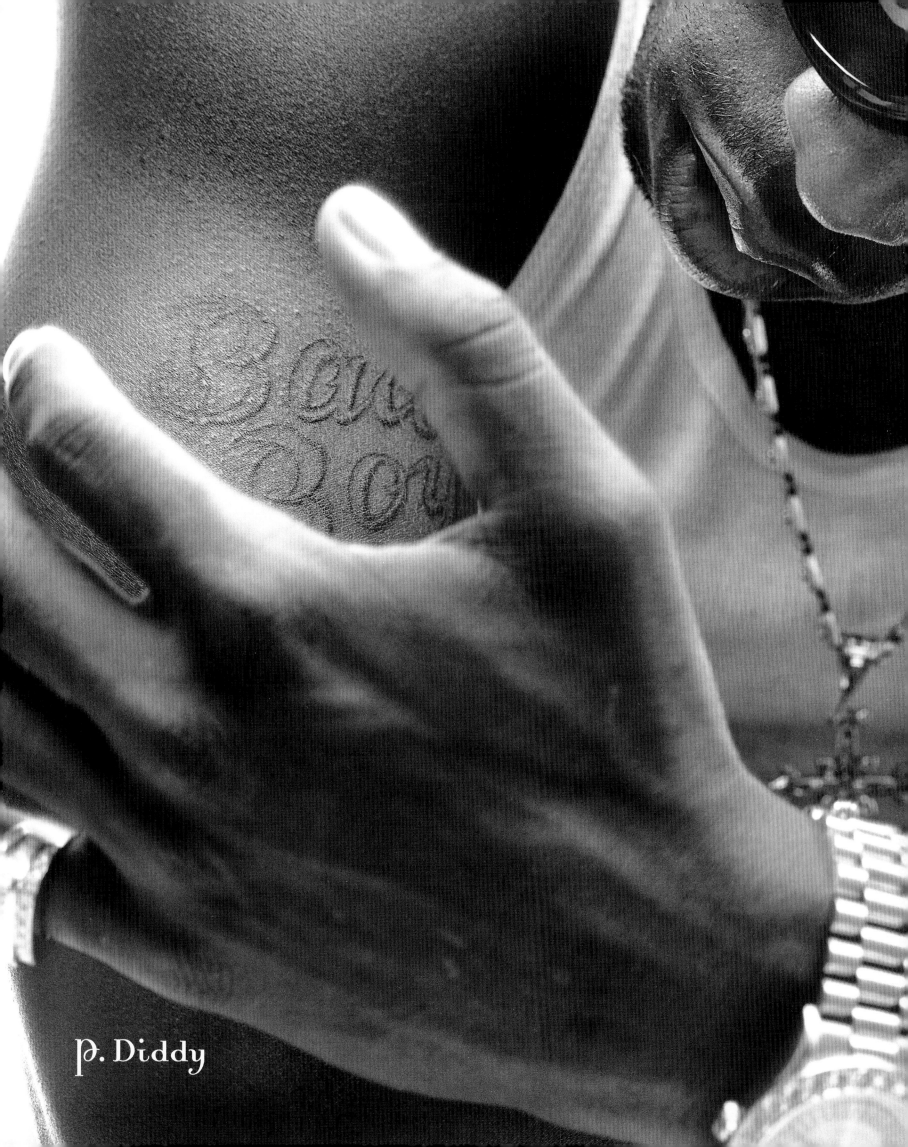

P. Diddy

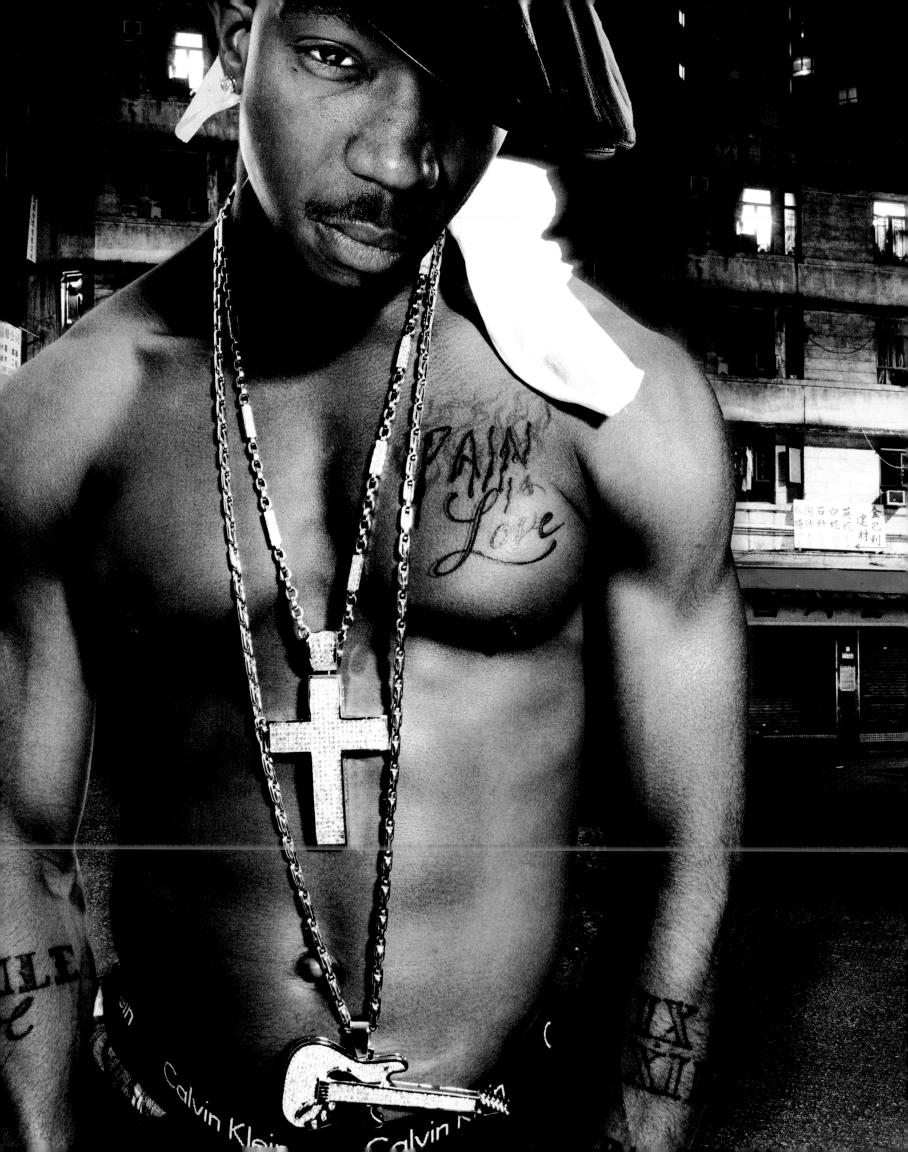

Ja Rule

I HAVE SEVEN tattoos. The one on my back is for my sister, Kristen, who died from respiratory problems when I was about five. I got this about two years ago – it's her name with angel wings and a halo – because I wanted to keep her with me at all times. It's like a statue, like I've immortalized my sister on my back. I really do feel she's my angel, watching me, making sure things go right. All my tattoos have meaning. I got "Pain Is Love" over my heart. It's all about sacrifice, like what Malcolm X and Martin Luther King went through for black people – all the pain, all the suffering, all the struggle, so

that people like me can receive some love. See a better day, so to speak. Like what Jesus did for mankind. He sacrificed his life so that we could basically see some type of life. That's what "Pain Is Love" is all about.

*Do you feel your tattoos
set you apart?*
Yeah, when people see someone with a lot of tattoos, they say you must be an entertainer or something, because you're not just going to be in regular society walking around looking like this. Either you're an entertainer or you're a madman. There's no in-between.

EMINEM

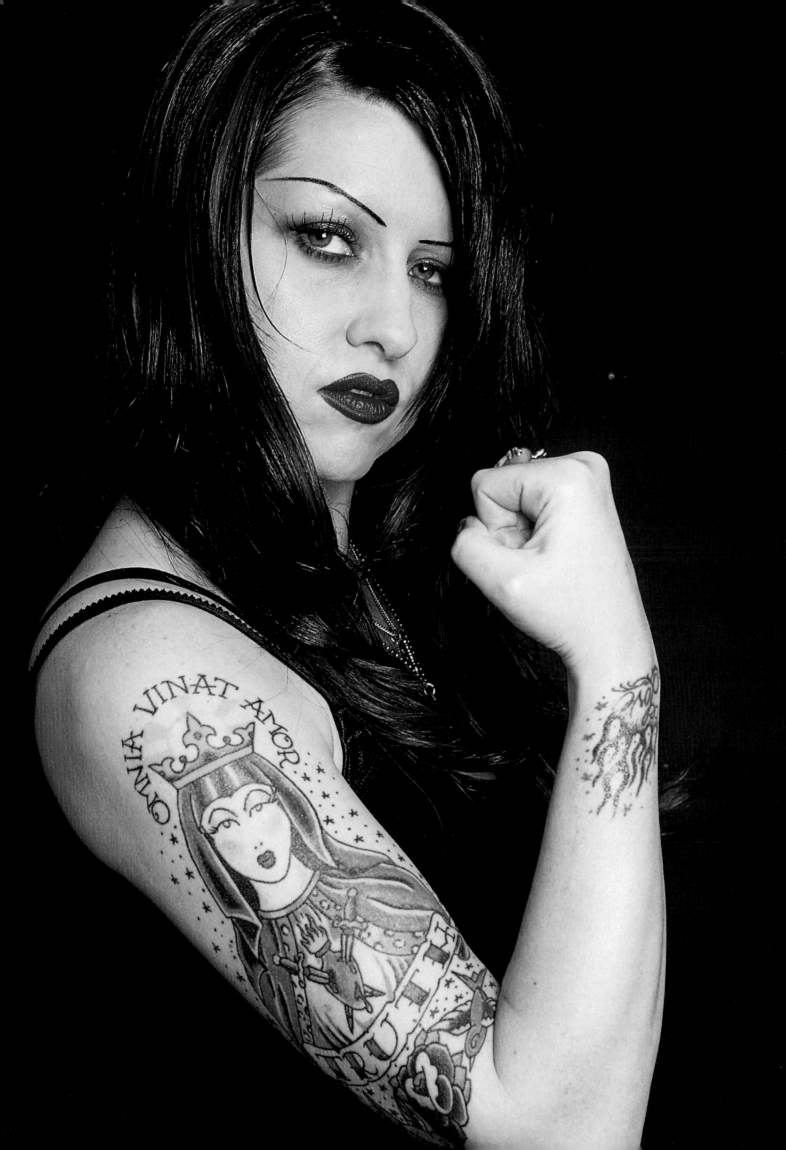

Tairrie B. *of* MY RUIN

My advice to someone thinking about getting a tattoo is: Know what you are getting and why you are having it inked into your skin forever. Do not just get a tattoo to be cool or hip, because that is bullshit and you will wish you hadn't in the long run.

Jacoby Shaddix

of PAPA ROACH

THE THING about tattoos for me was that once I started getting them, it was like, "Oh, shit, I'm addicted!" The first one I got was my wife's name, "Kelly," in Old English all the way down the back of my arm. It's pretty darn fucking big. This was back when I had a normal job, before my band was signed. I worked as a janitor at an air force hospital, and everybody else there was jealous because they couldn't get tattoos. The generals would look at me like, "Who's this kid?" I was the punk rocker with piercings and tattoos.

The second one I got on my forearm. It's an old vintage microphone. I was totally dedicated to my band, so I was like, this is going to be something that I'm into for my whole life. Fuck it – I'm going to go get it tattooed on my skin, so I wasn't going to ever be a worker after that.

On my left arm, I got a big burning house, and then underneath it, on a burnt-looking banner, it says, "What Doesn't Kill Me Makes Me Stronger." And that represents my family – my family fell apart when I was young – and it's also my earliest childhood memory, from when I was probably, like, six, a burning house. "What doesn't kill me makes me stronger" is the lesson I learned over the past twenty-five years of my life. I look at that all the time.

Now I'm getting a big cockroach tattooed on the inside of each bicep, so when I lift up my arms you'll see the head and the antennae sticking out of my sleeve. My great-grandfather on my stepfather's side has the last name Roach, and we called him Papa Roach, and that's where the band's name came from. But then it evolved into the whole cockroach thing, survivalists – the what-doesn't-kill-me-makes-me-stronger kinda thing.

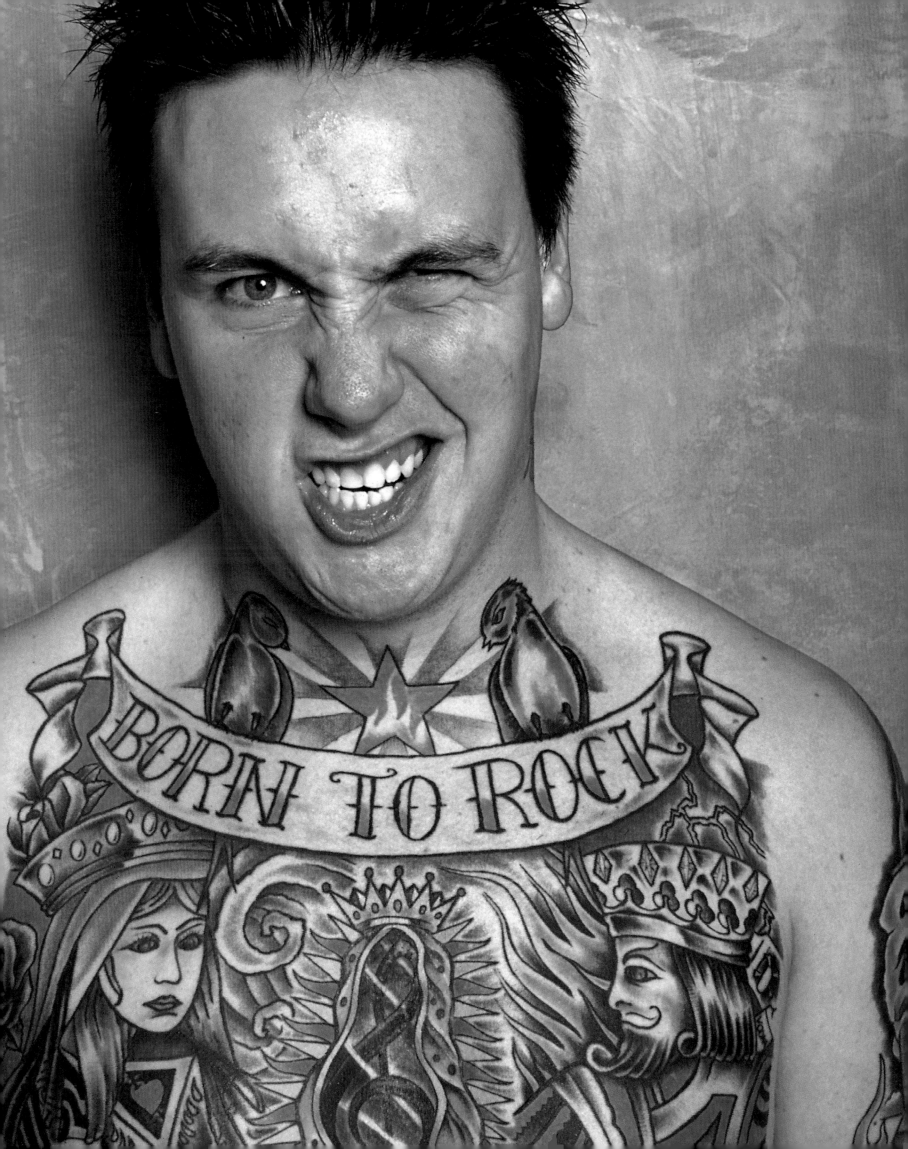

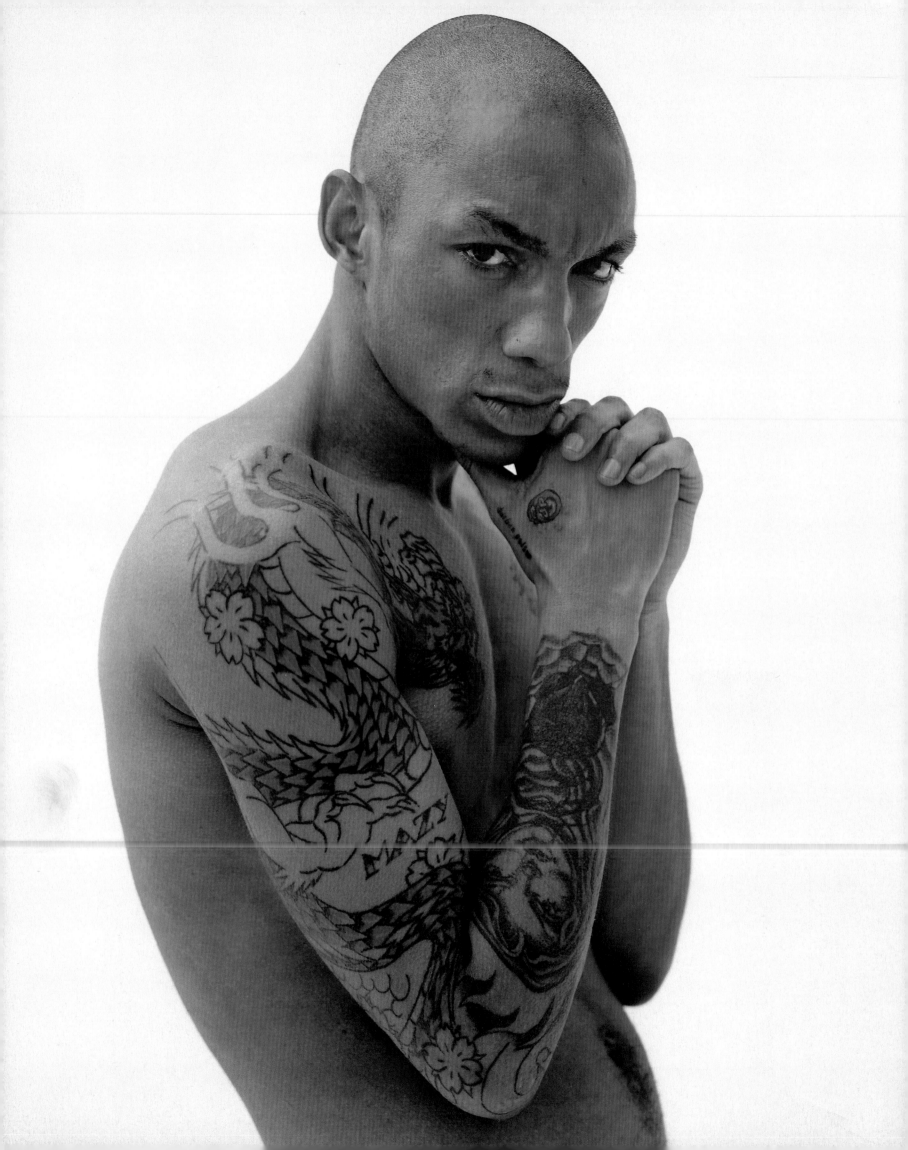

Tricky

I WAS HANGING OUT in Japan and I met this guy, and we went to a tattoo shop, and I just decided I wanted to get a full Yakuza shield. I've been working on it for a few years now. There's a girl on my forearm – she's gonna have cherry blossoms all over her face when she's finished. A dragon is going to go around her a little bit. I'm not into having Mickey Mouse or anything like that. These are very traditional. I've got the dragon and the tiger on my chest, but the eyes won't be colored in until the end, because that's the last time I'll see my tattooist. And they won't go over anyone else's tattoos, and they have to practice on themselves before they touch anyone else. So you go into the shop, and they're tattooing their legs. It's real spiritual. They take pride in what they are doing. At the end, he'll sign his name on my body.

* * * * *

ON MY ARM, I have my daughter's name. She's everything, really. Before she was born, I really didn't give a fuck. I always thought I was gonna die young. When she was born, that changed. It became imperative that I stay alive at least until she's sixteen. And I know that's gonna happen now.

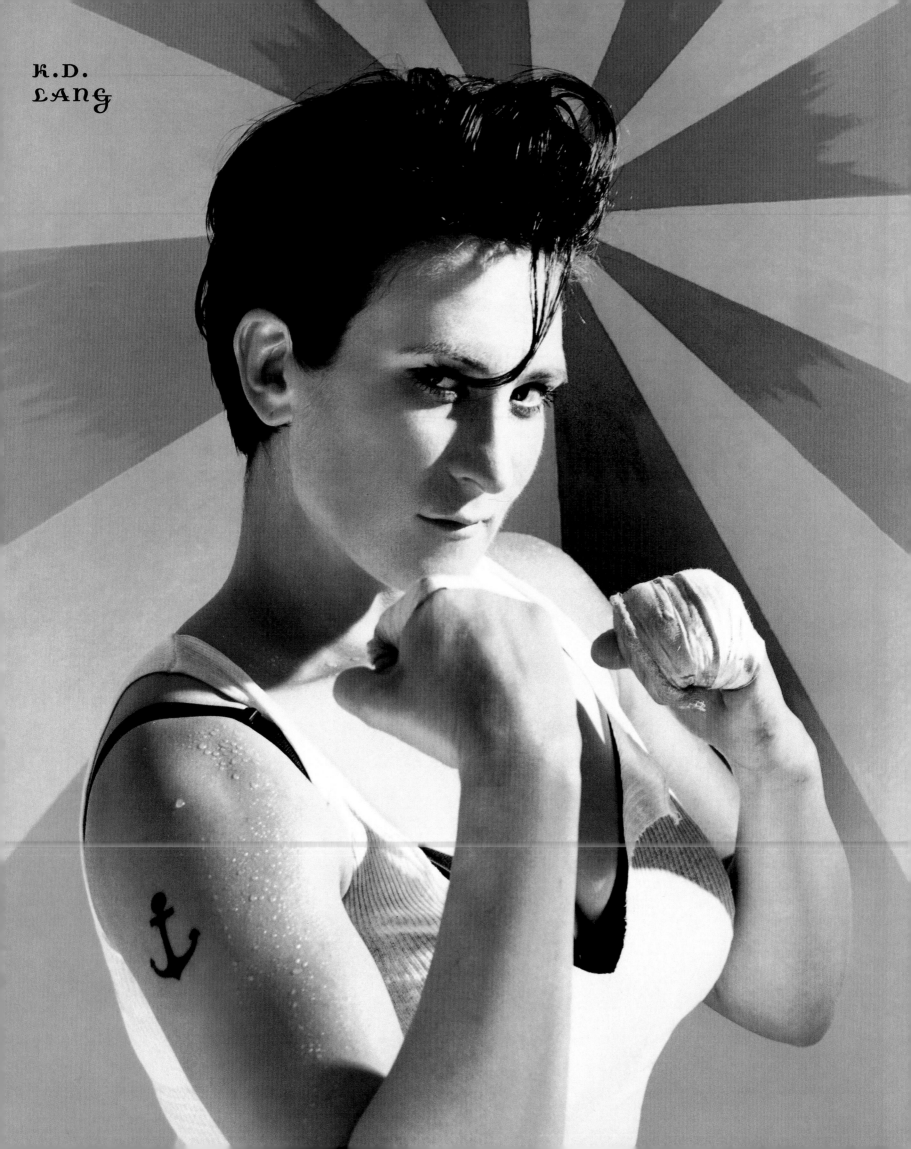

K.D.
LANG

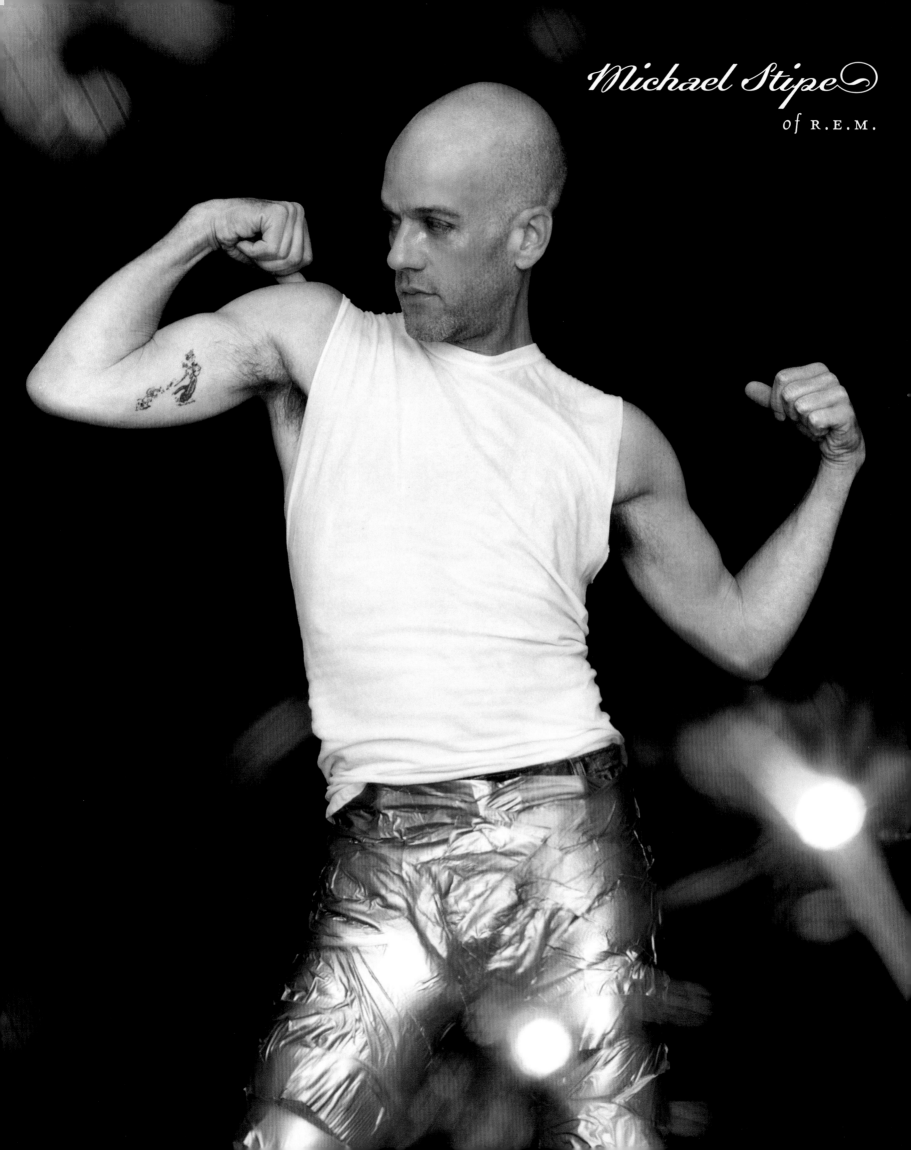

Michael Stipe
of R.E.M.

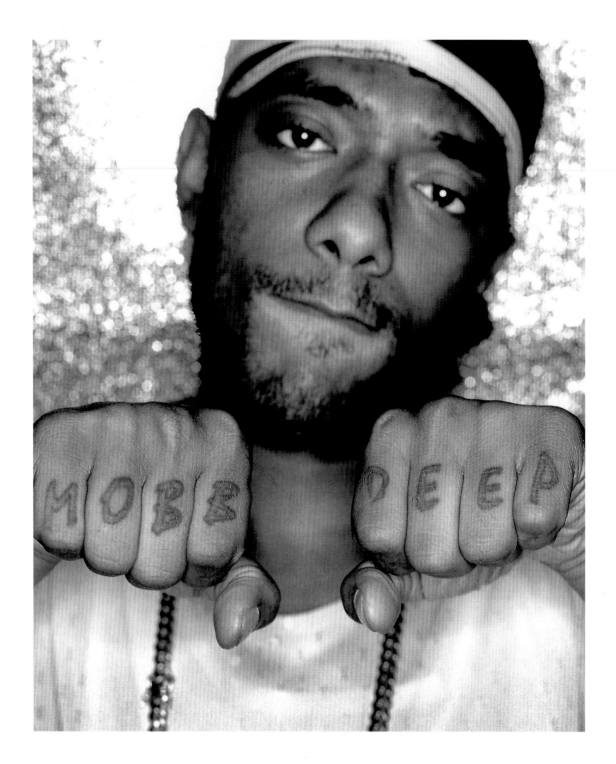

I've spent six years expressing myself
with my body, shouting with my body.
It's like a conductor of the music.

—*Prodigy*

of MOBB DEEP

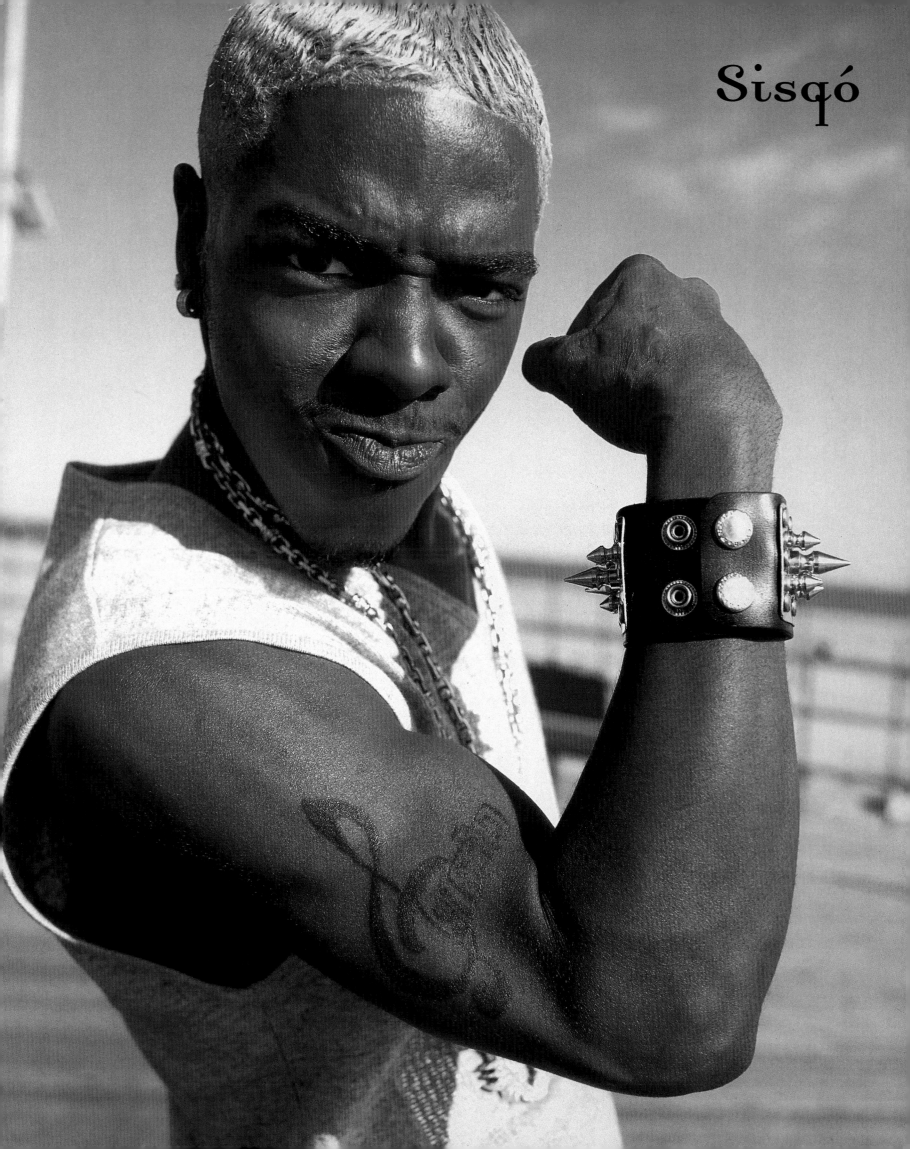

Sisqó

They keep
procreating,
like rabbits.
—MARK
McGRATH
of SUGAR RAY

Dryden Mitchell

of ALIEN ANT FARM

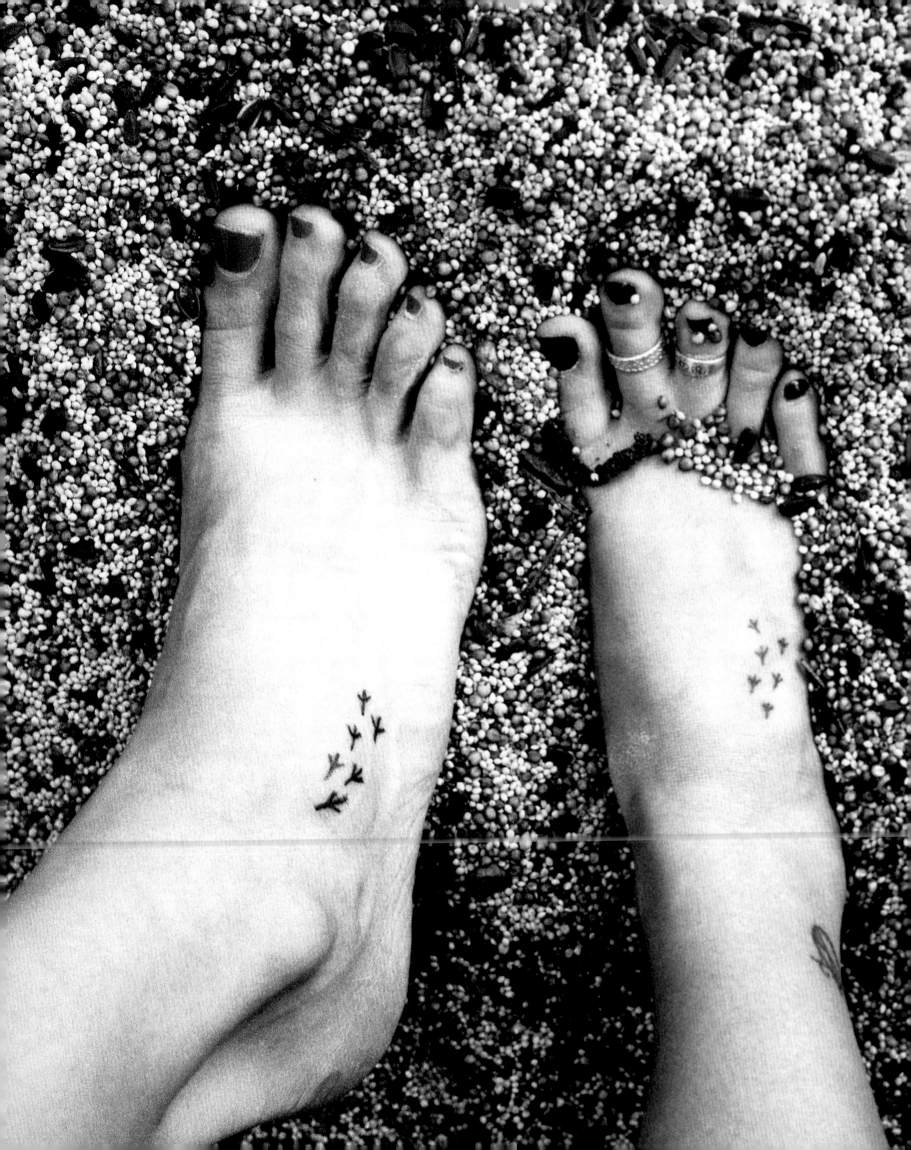

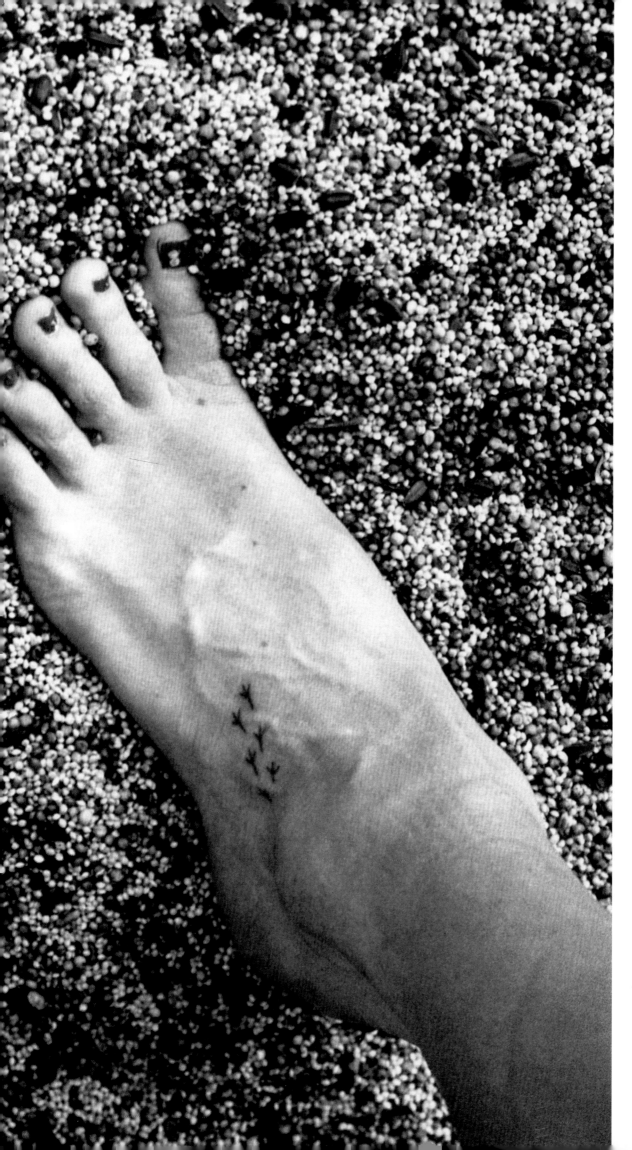

Dixie Chicks

T WAS an agreement we made when our first album came out. Jokingly, I said that for every Number One record we had we should get a little chick's footprint tattoo on top of our own feet, and the other girls agreed. I already had a tattoo, and they were not tattoo people, so I could not believe they went along with it.

My first tattoo was the world with the Latin word for "peace" on top, which is *pax*. So, peace on earth. I got it when I was seventeen. I used to draw that all the time, just doodling in school and stuff. My dad took me, of all people. My mom made him go with me because she was scared to death that I would get AIDS. My dad even paid for it – it was twenty-five dollars – and he took me and was there to report back to my mother that the needle was clean and brand-new. I was of age to get it, and he knew I would get it anyway. And they would rather have known it was safe and to have been there. Why did he pay for it? Now that's the amazing thing. I got it because I was very into Lenny Kravitz and the whole *Let Love Rule* album, and its message was just my life. So I wanted to mark myself with that. I will never regret that tattoo. I think peace on earth is always a wonderful thing.

I picture being an old lady with wrinkly feet, explaining the tattoos to my grandchildren and great-grandchildren, because I'm sure they won't even know who the Dixie Chicks were. And I'll be telling them, "No, really, we had all these Number Ones." Now our fans get them. And radio stations have made fans get them to win front-row tickets. And I'm just going, "Oh, my God." I think now we're getting too many chick feet, and they're not the most attractive thing to have when you're wearing a nice elegant heel. But how can you bitch if you've had that many Number Ones?

–NATALIE MAINES

Left to right: Emily Robison, Natalie Maines, Martie Seidel

was so big, but after a while, I think she dug it. —Lenny Kravitz

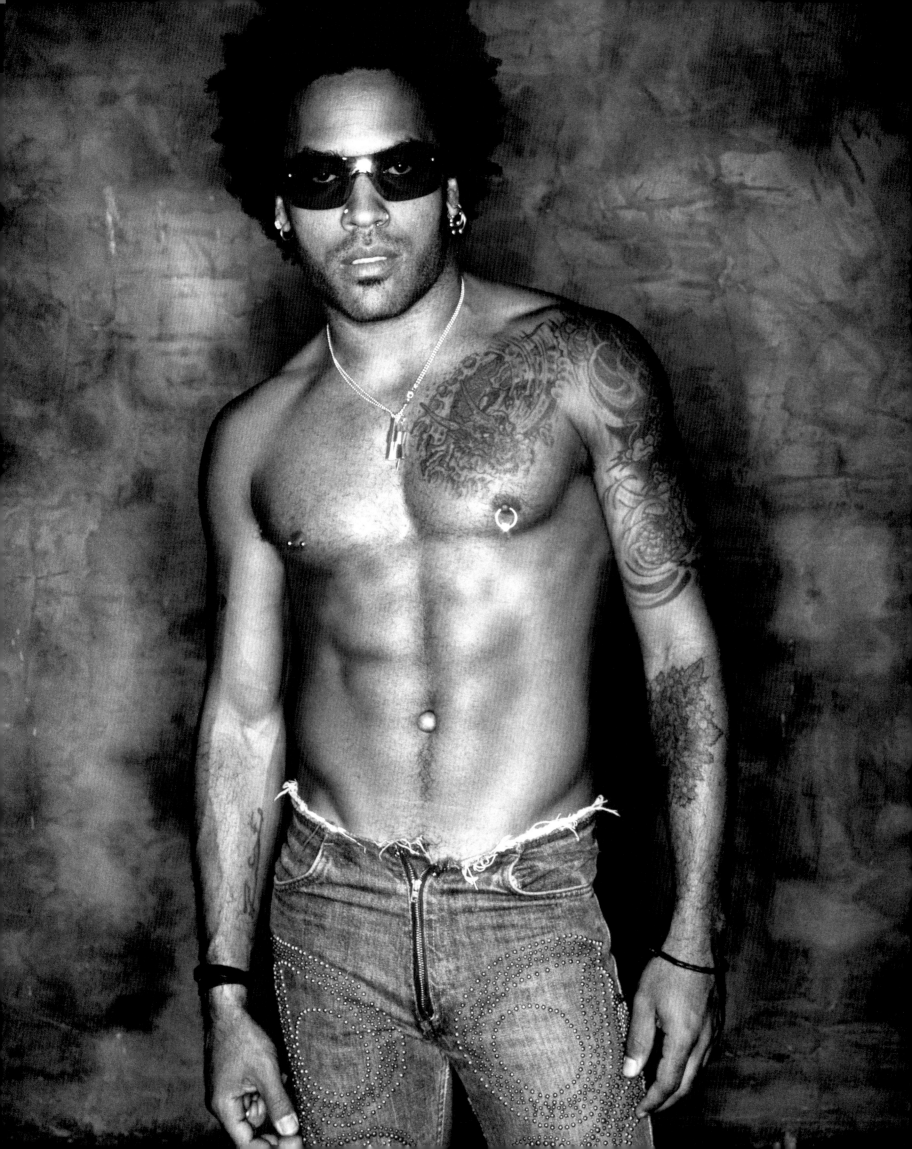

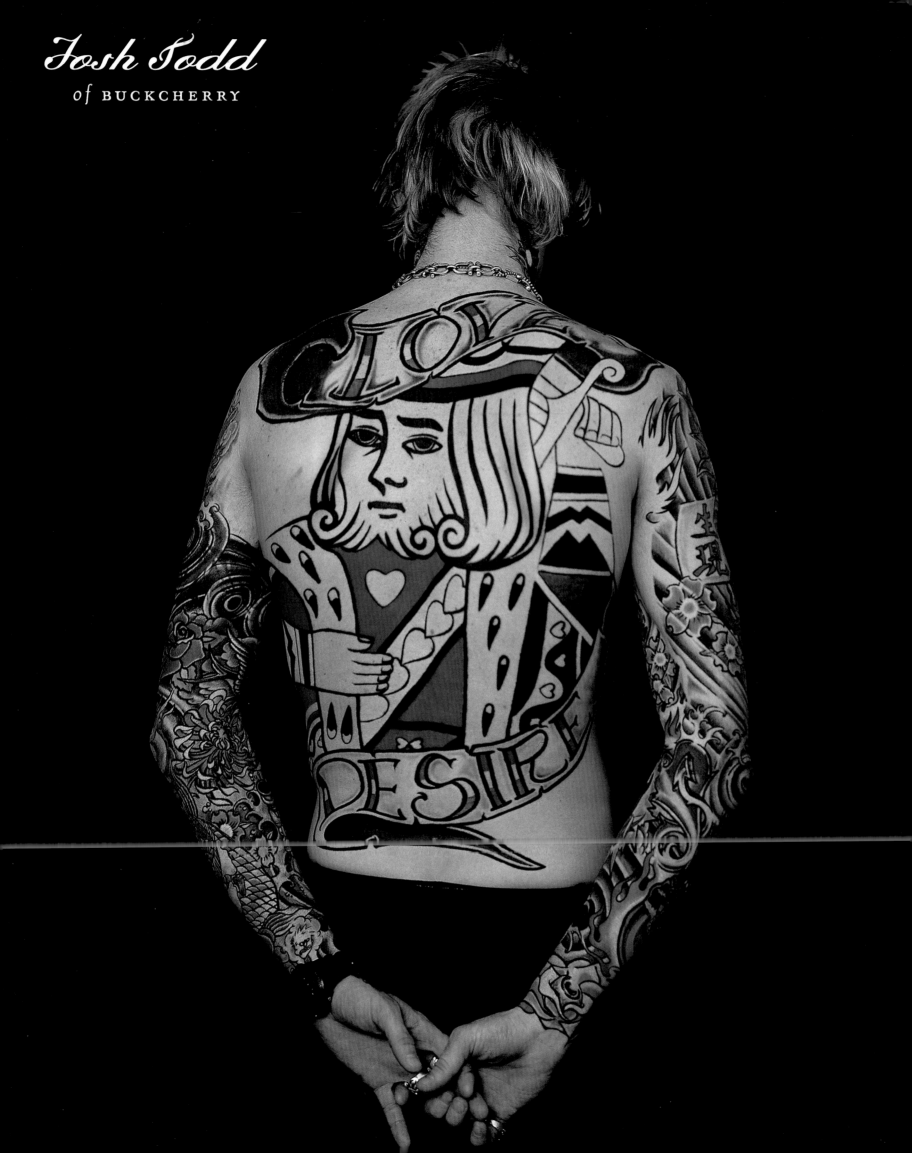

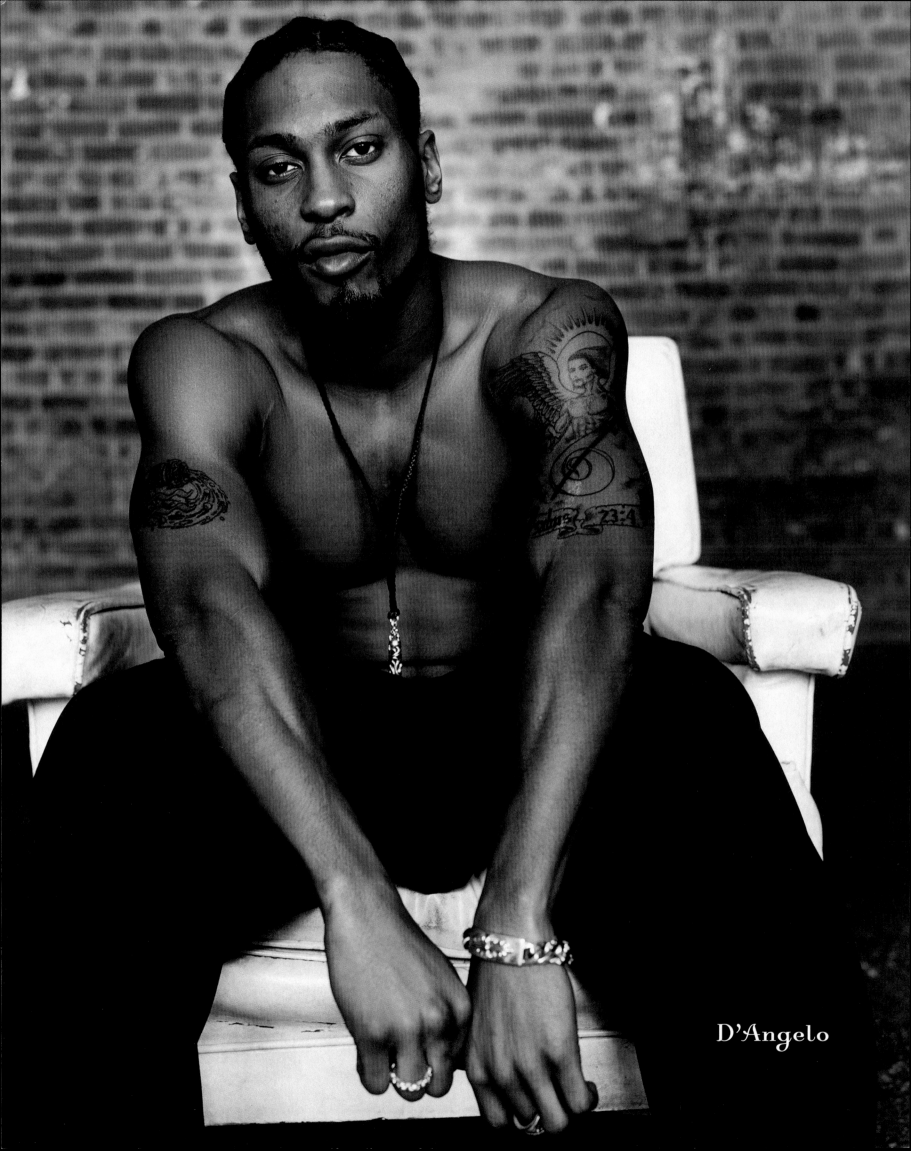

D'Angelo

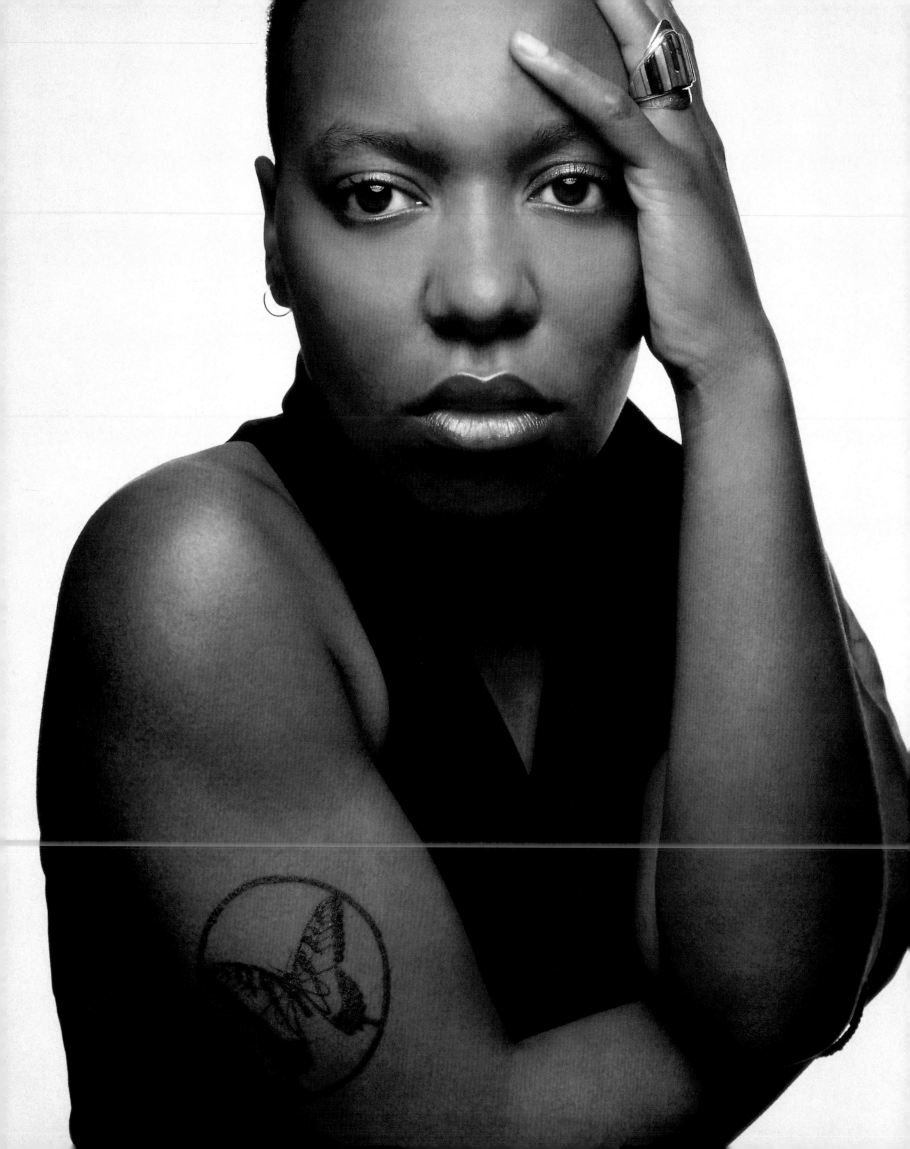

I HAVE THE BUDDHA of compassion on my right arm because I needed to tap into my compassionate self. Being in the record business, you've got to be high-minded. Being of African descent, I guess it's some sort of initiation for me in my subconscious, a way to adorn my body as I'm going through all these changes. And it just reminds me of stuff. Like a map. I like to look at it and see what's going on.

At the top of my arm is a Madagascar moth. It's probably the most peaceful creature; they don't do anything but head toward the light. This was a good symbol for me. They're just chillin'. They're super laid-back. And then I have my girl-friend's name on my neck . . . just to have something so everyone can see the com-mitment you've made to that person – I like that. Her name is Rebecca, and it's done in English cursive. We've been dat-ing five-and-a-half years. And then I have Arabic on the other side of my neck. It means, "There is no God but God."

* * * * *

GEORGE BUSH needs to get a tattoo. He needs to tap into some other shit. He needs to get "I Won" somewhere on him so he can deal with this shit. He needs to get something to commemorate that, because it's not going to happen again. Israel and the Palestinians, they need to get tattoos that say "Both of Our Fathers are Abraham." Both of our fathers are Abraham, and we're fight-ing over some dirt. Bill Clinton should get one somewhere on his body. I think he's got a tatt – a naked woman, and when he flexes his arm, her booty moves.

Brandon Boyd
of INCUBUS

I got my first tattoo when I was fifteen. My older brother, Darren, and I both had dream catchers done. Mine is on my hip, and his is on his forearm. They're not identical, but they're similar. So it was a bonding thing for us.

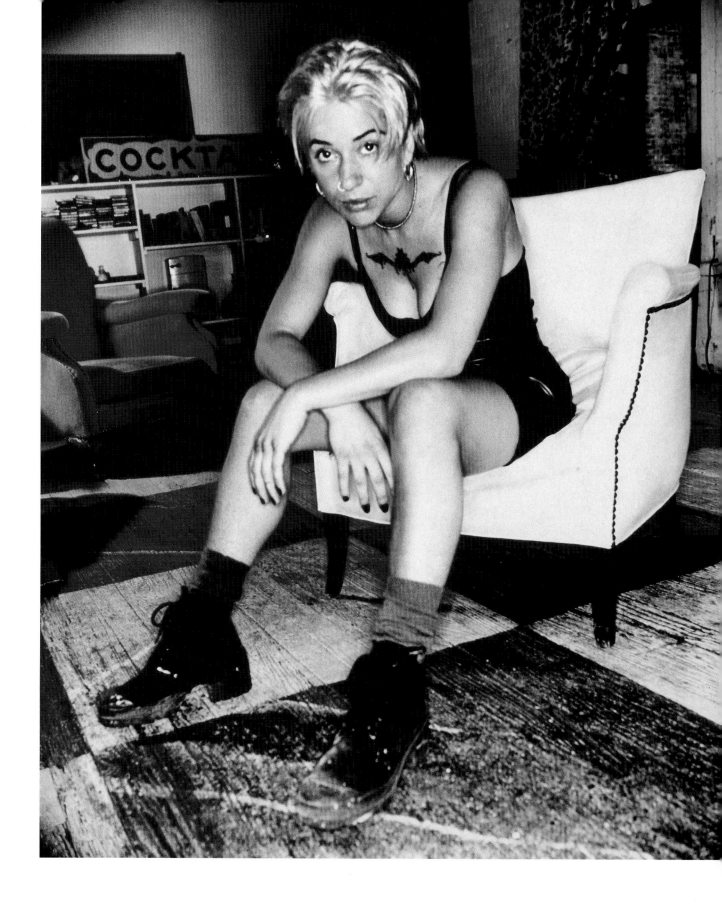

They're mile markers, road maps,
pictures of places I've been to.

—Ani DiFranco

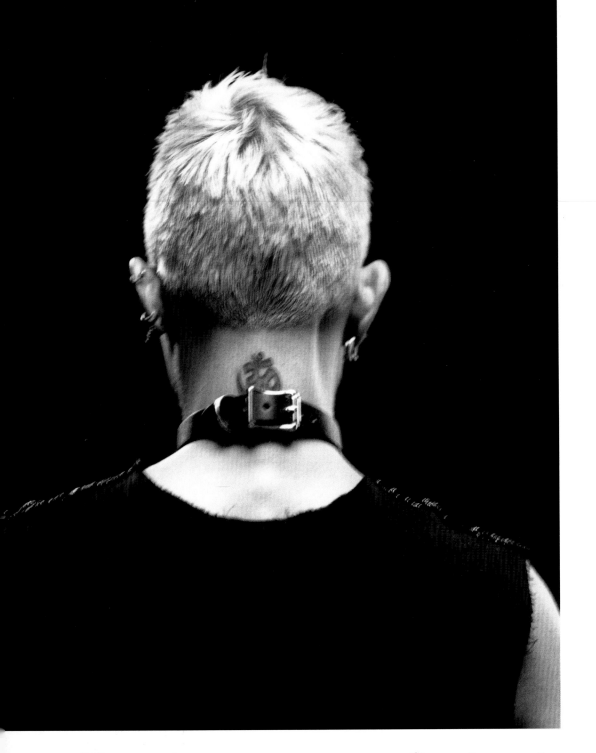

Moby

When and where did you get your tattoo?
When I was twenty-eight years old, in Dallas.

Why a cross, and why there?
The back of the neck is like a billboard. And that's what I chose to advertise. I love Christ and the teachings of Christ. That's important to me. Christianity much less so.

Does the tattoo serve as a reminder of your faith, or of a moment in your life, or something else?
It's like being branded. Like a cow.

Why do musicians get so many tattoos?
Because we don't have day jobs.

There's one on my neck, there's one on my hip, one on my lower back, three on my arm and one on my ankle. I think that's it.

—Joan Jett

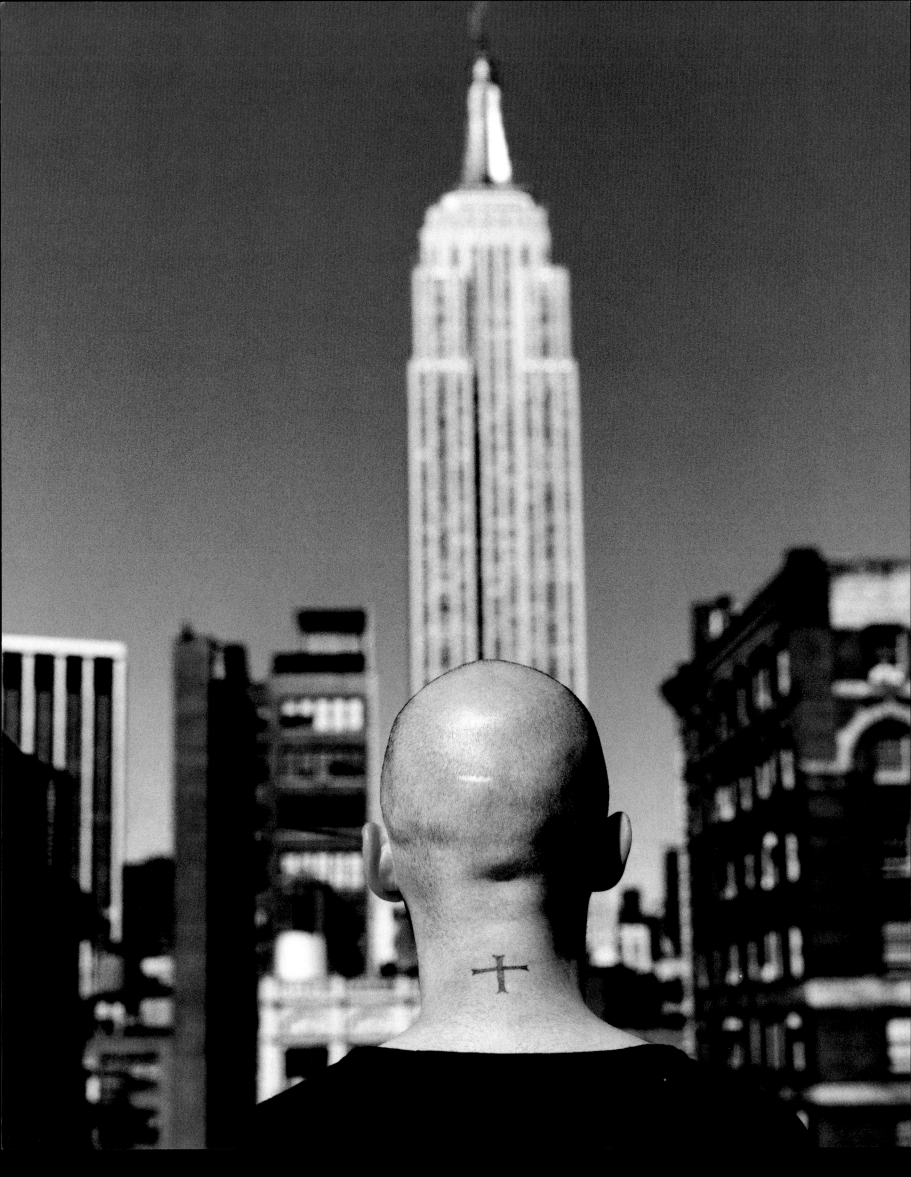

I should have been born with these on. They are unnatural. You have to go get this done to you. That is perfect in my mind. That's how unnatural I feel in the world.

—HENRY ROLLINS

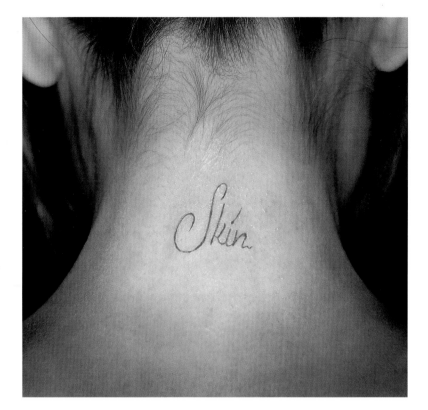

Melissa Etheridge

I WAS TURNING FORTY and breaking up a twelve-year relationship. And so I really was looking at myself, gathering myself together and having an experience that was very singular and alone. I knew it was a big turning point in my life where I was going down a different road, and I had always flirted with the idea of some sort of tattoo because I find them very expressive. So I said all right, I'm going to do it, I'm going to do it. I knew I was going to, but I wasn't exactly sure when. But I wanted to mark this time in my life and express the new person that I was becoming. Kind of like, okay, let's not ever forget this.

So I was making this album, and the album was my artistic way of trying to understand this experience and get it out and go through it. After I had written all the songs, I noticed that many of them had the word *skin*, used differently – getting out of my skin, and my skin is brand-new, and skin being touched, and really coming into my skin . . . just all these terms about my skin. I realized that what I was going through was a metamorphosis. And then I was like, you know what, now I'm going to get a tattoo.

I had seen this wardrobe assistant who had a white tattoo – she was a very tan person, which makes a big difference – and it was very beautiful. I'd also seen someone else who had kind of a dragony-snake white tattoo that looked like scales on his shoulders and arms, and I was like, that's very cool.

So I called the tattoo artist, and I said, "Abel, I want a white tattoo," and he said, "All right, come on over." So I went out and had some sushi and a little bit of sake and called the photographer who was shooting my album cover, and I was like, "I'm getting this tattoo," and he said, "Can I shoot it?" and I was like, "Be there in thirty minutes." The tattoo itself took about five minutes because it was just the word *skin*. The photographer was there, and another friend, and the photographer's assistant, and of course the whole tattoo parlor came out to watch Melissa Etheridge get a tattoo, so a bunch of strangers were there, too. I got it on the back of my neck, which is very sensitive but also very sensual. When it was done, my neck was all sore and everything.

It's such a thing to do for yourself and to yourself, and it really freed me up when I gave myself that experience. It's something that's you, that's yours – it's how you love yourself, it's an experience with yourself, it's very strengthening. There was a certain amount of closure to it, and it was the beginning of the rest of my life. It was a real mark on the time line. I'm definitely going to get another one.

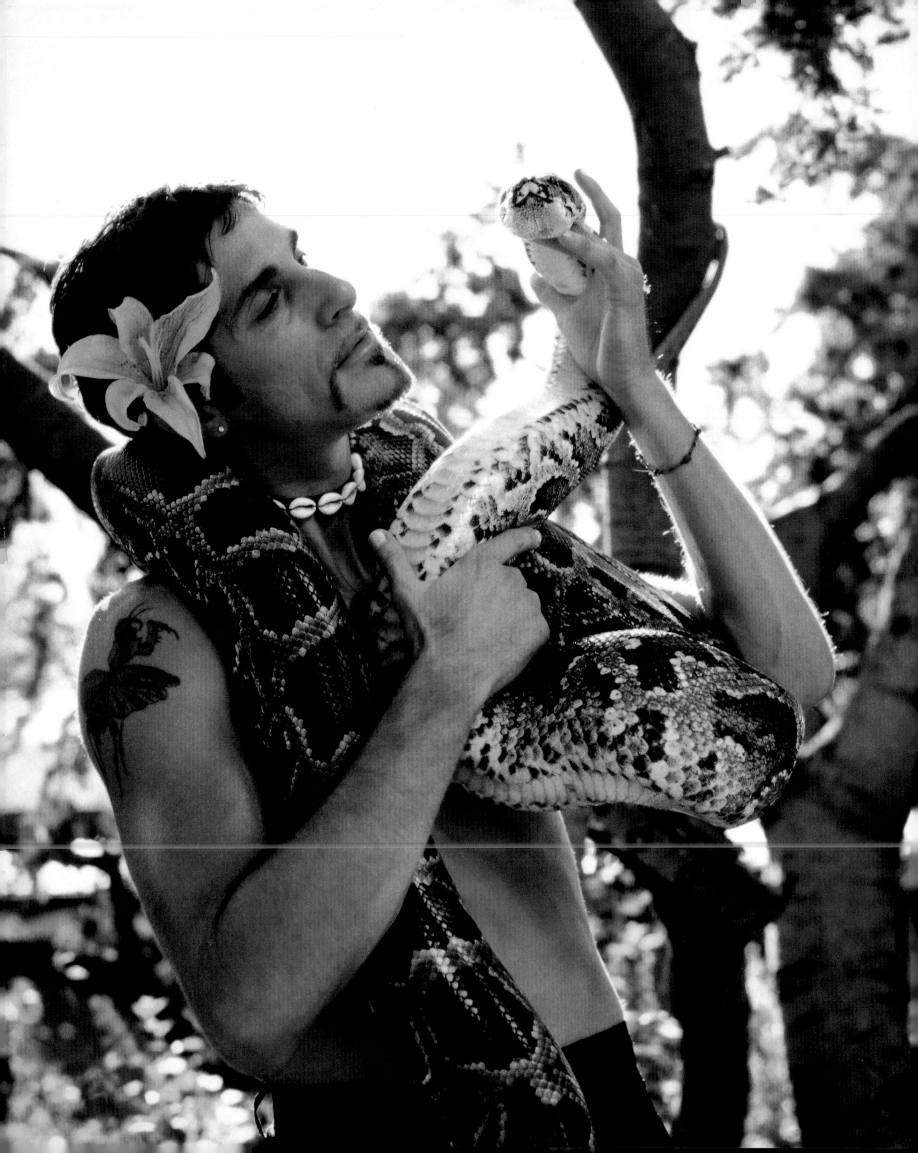

We're entitled to celebrate our flesh...you celebrate the flesh and you look at yourself and you see the flesh and you pierce the flesh and you tattoo the flesh, and then something happens.

—Perry Farrell

Drew Barrymore

I GOT MOST of my tattoos when I was thirteen. I went tattoo crazy and got six of them between the ages of thirteen and sixteen. I got the angel tattoo because I love angels. The last one I got, when I was sixteen, was a butterfly. I have a cross on my back and one on my ankle – the one on my ankle I drew myself, and I sort of did that because I believed that religion and spirituality were everywhere you looked and everything was possible. Even when I was really young I was on the brink of that, and I have always loved spirituality and nature.

The butterflies – I love the metaphor of butterflies, that you can actually change and metamorphose and grow and become a more profoundly beautiful and capable human being. I think that's really important, to believe that you can always change and grow and become better and become more capable.

* * * * *

THE FLOWER TATTOO ON MY HIP is, like, the first one I got, and when I walked into the tattoo shop I really wanted daisies, because that was my favorite flower, and the guy didn't even know how to draw a daisy. So he was like, "You get a rose." So I said, "All right." I just wanted one so bad that I got a rose, then I added daisies to it later. That was my first-try tattoo, and it's not really that cute, but I like it. It reminds me of how I would have taken anything, not necessarily the thing I wanted. Now I have a great deal of patience.

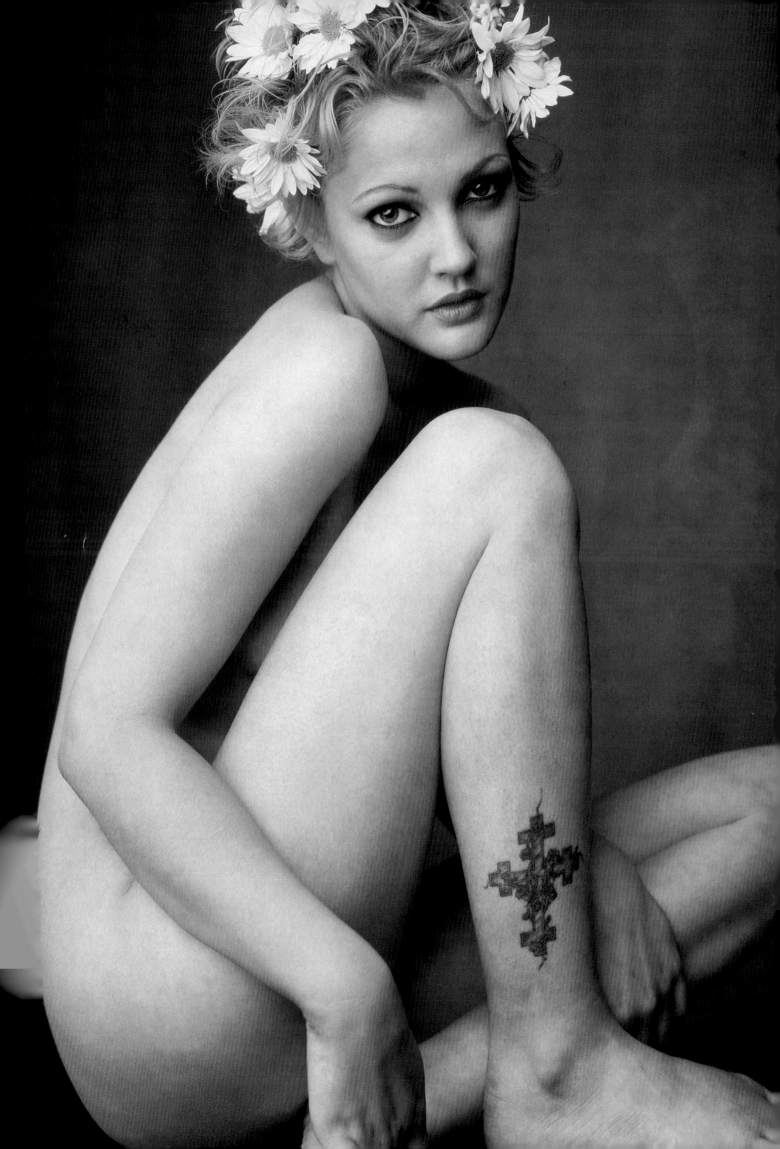

Rose McGowan

Courtney Love

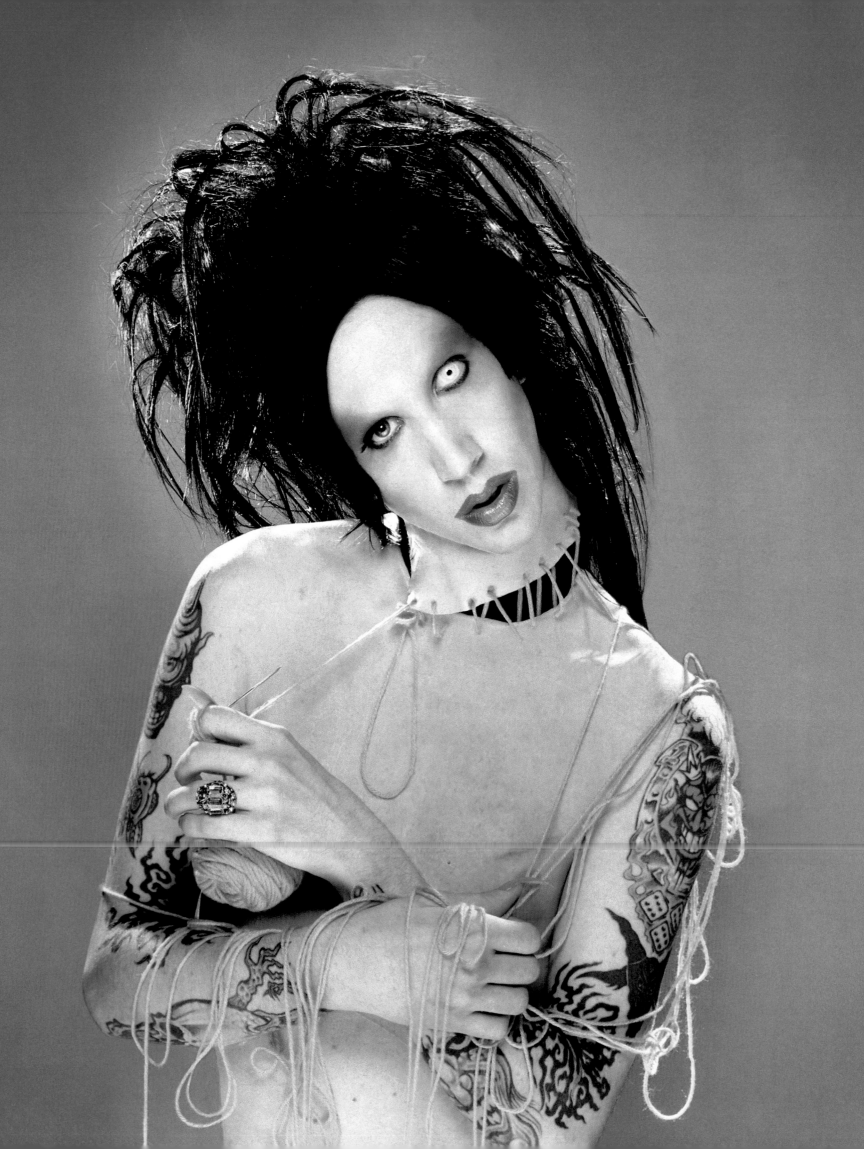

Madonna's label was interested in signing us. And her manager called my manager and said, "I noticed that the singer has a lot of tattoos. He doesn't have any swastikas on him?" He said, "No, of course not; one of the guys in the band is Jewish." "Oh, okay. We don't have a problem with the Satanism, but we can't deal with any kind of Nazism."

—Marilyn Manson

Nikki Sixx

of MÖTLEY CRÜE

THE PROBLEM IS that so many bands sit back and say, "Okay, let's get a tattoo, do a photo on a Harley, hang a cigarette out of our mouth, and we'll make a quick buck because that's rock & roll." But it's not a cliché to us, because it's real.

The difference between tattooed people and nontattooed people is that tattooed people don't care that you're not tattooed. So when someone sees my hand and it freaks them out, I know they're the kind of person that I probably don't need to know, because they're very superficial and they're very judgmental. Do people react badly? Yeah, some people ask to be moved to a table farther away. Little old ladies come up to me and go, "What the hell did you do to your body?"

—Evan Seinfeld

of BIOHAZARD

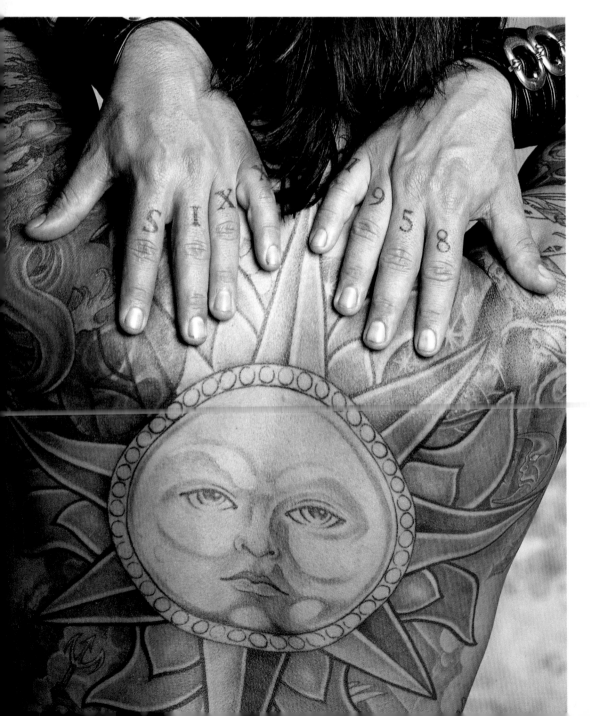

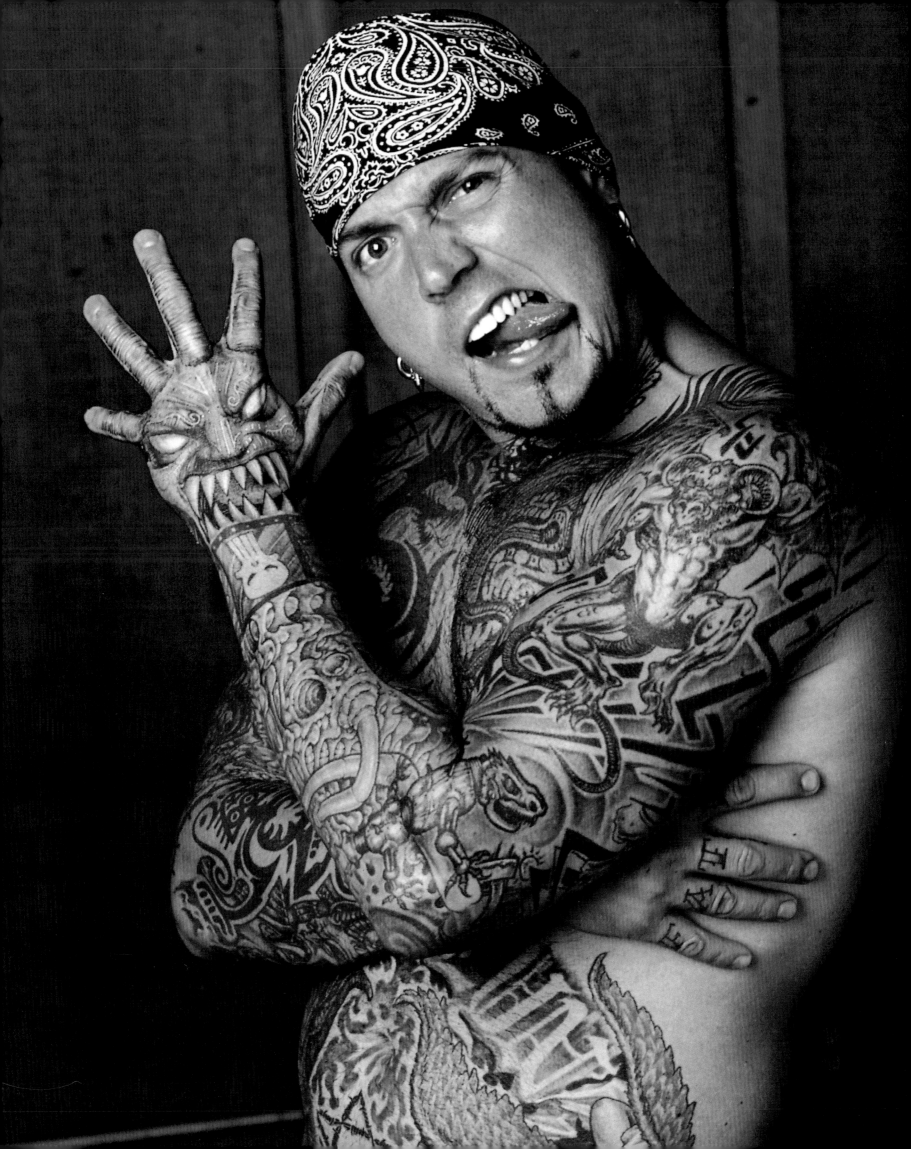

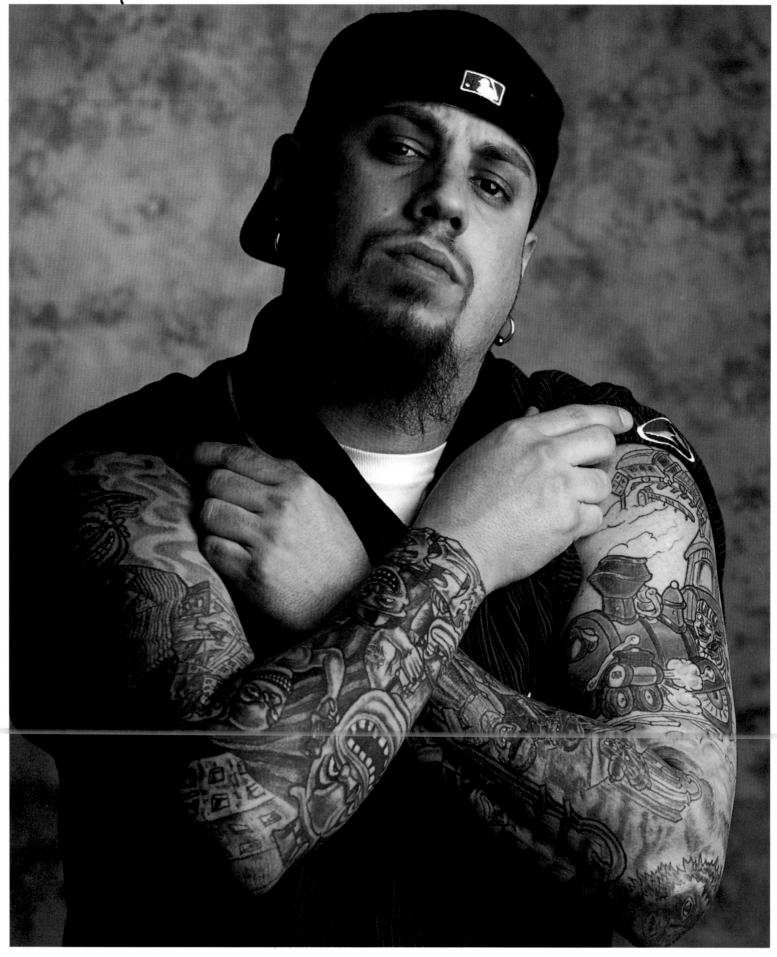

Fieldy of KORN

Cypress Hill

Left to right: B-Real,
Sen Dog, DJ Muggs

What inspired me to get tatts of my friend Boomer, who is a dog, was that he really was my best friend when I had nothing. He was there before the DMX fame – Boomer and I did everything together, and he never changed with my status. He's a pit bull who is still very special to me.
I have dogs and believe that every dog should be treated with care and respect.

–dmx

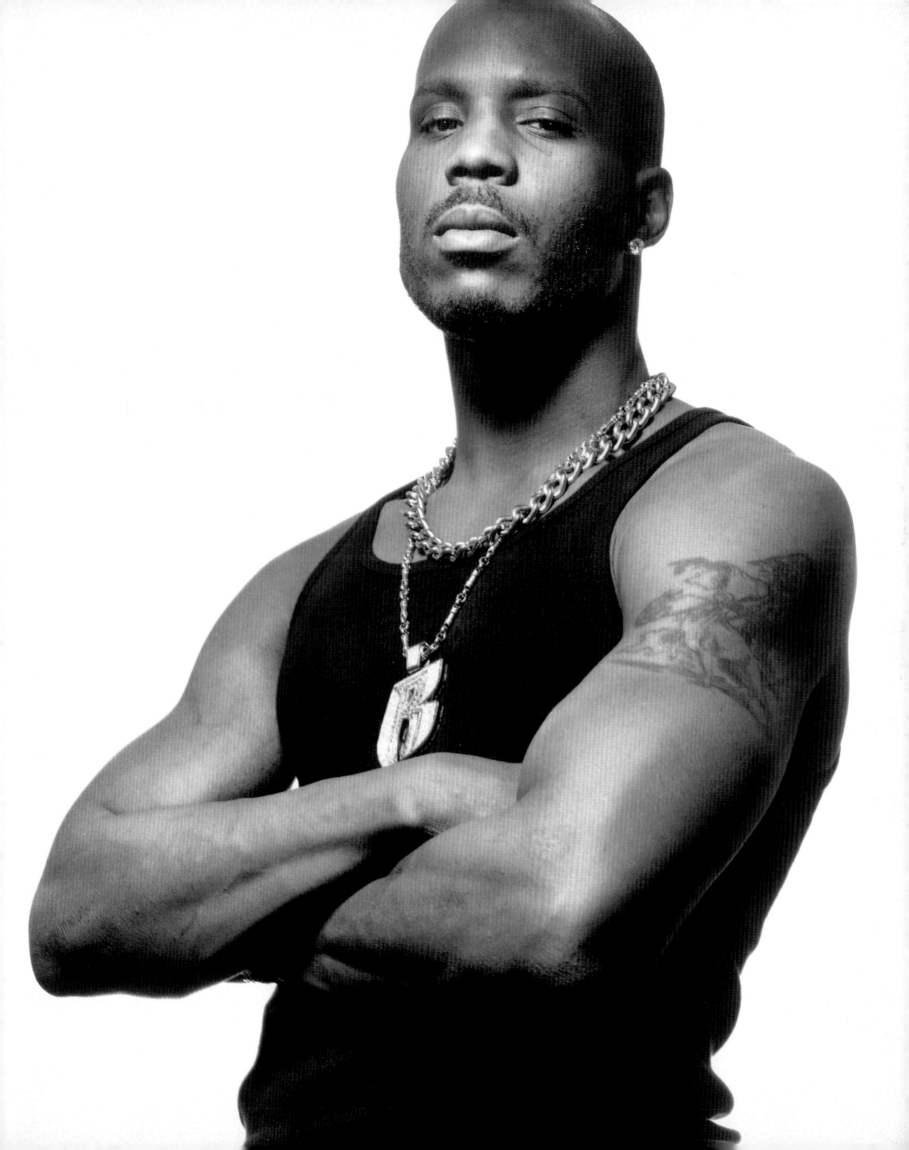

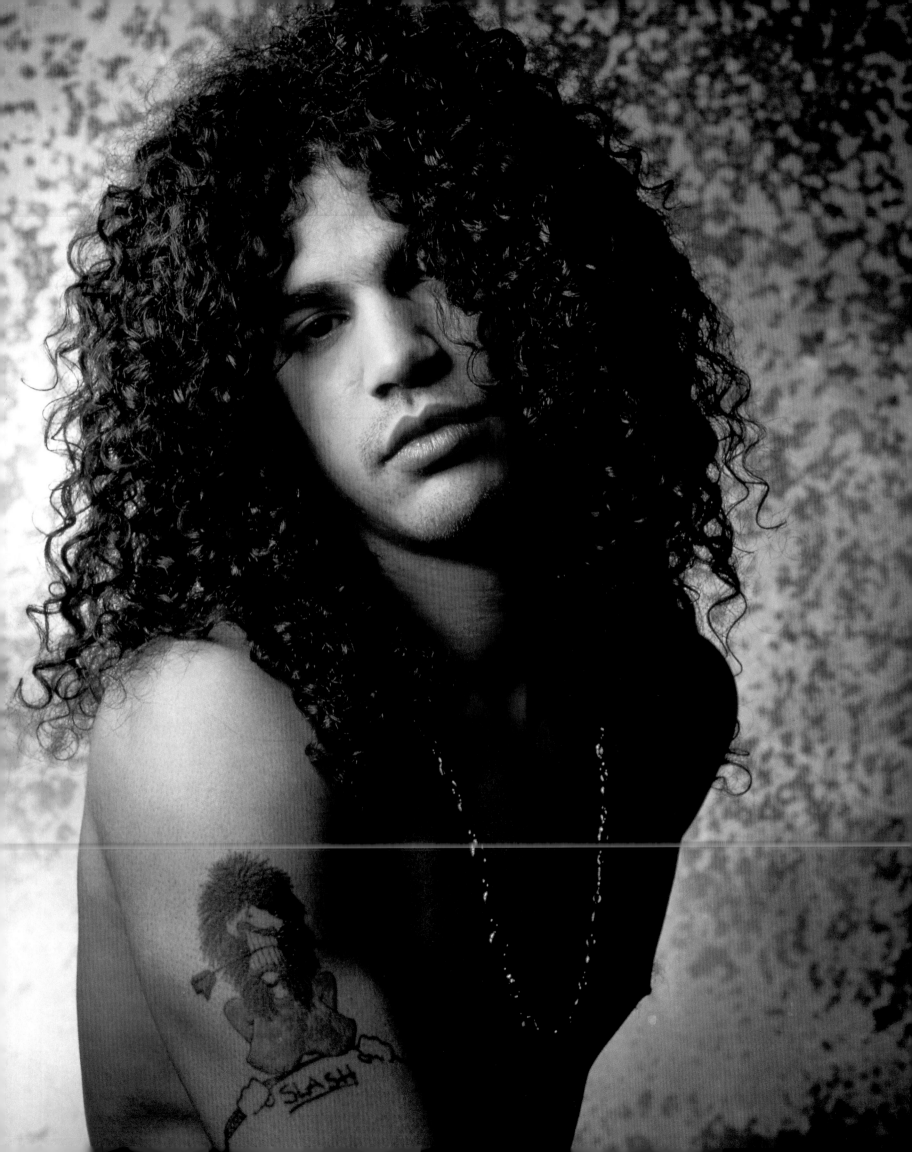

Slash

THE CHICK with the whip and my name under her was my first tattoo. I got that when I was about fifteen, in my last efforts at high school. It's a fictional cartoon character named Shirley. And there's a story behind it: It was my drummer's mom's name. This was one of my first bands, and we used to rehearse in his garage. And his mom used to come out screaming at me to turn it down. That was her thing, every single day, about four times a day – because I was always too loud – pushing the garage door open and screaming at the top of her lungs. The picture doesn't look anything like her. I just drew it and decided to get a tattoo of it. I was sitting in class one day, drawing on the back of some sort of book report I was supposed to turn in, and I drew this picture of a girl screaming at the top of her lungs at her boyfriend, who was a guitar player.

AXL
ROSE

Rob Zombie

You want one, you get one. It hurts. You like it or you don't. I always come up with an idea at the last second and say to myself, "Gee, I hope I like it tomorrow."

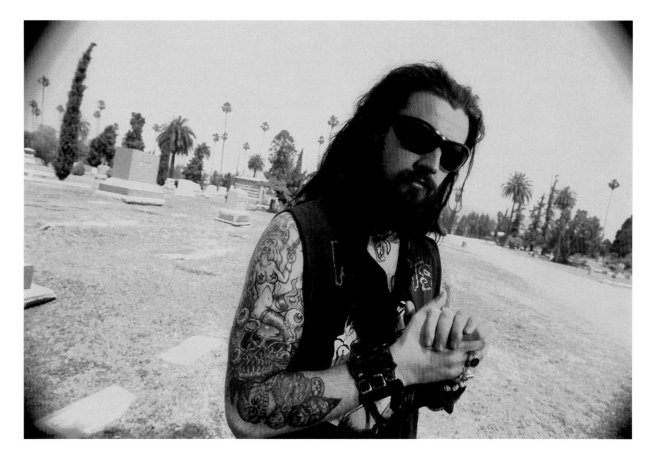

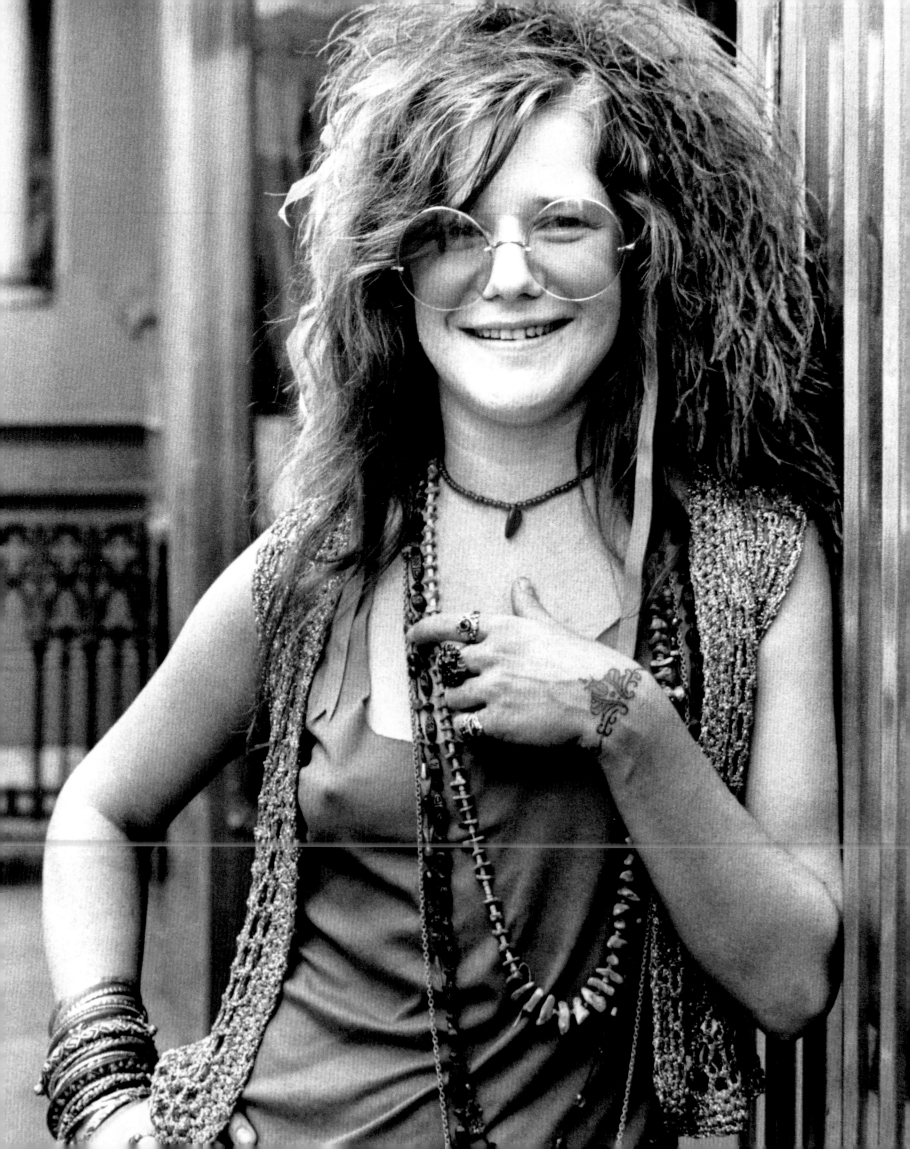

The one on
my wrist is for
everybody.
The one on my
tit is for me and
my friends.
Just a little treat
for the boys, like
icing on the cake.

—JANIS JOPLIN

Tom Waits

I've got a map of Easter Island on my back. And I have the full menu of Napoleone's Pizza House on my stomach. After a while, they dispensed with the menus. They'd send me out, and I'd take off my shirt and stand by the tables.

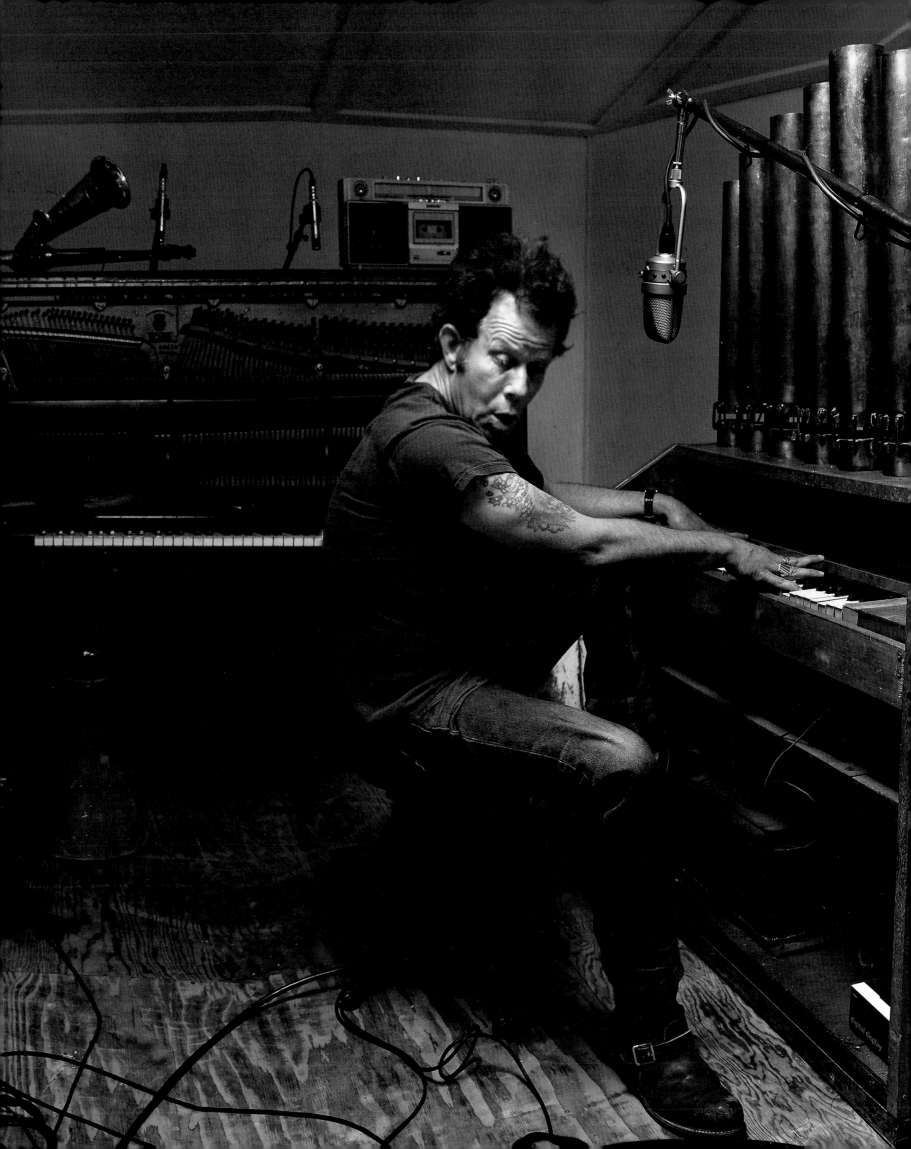

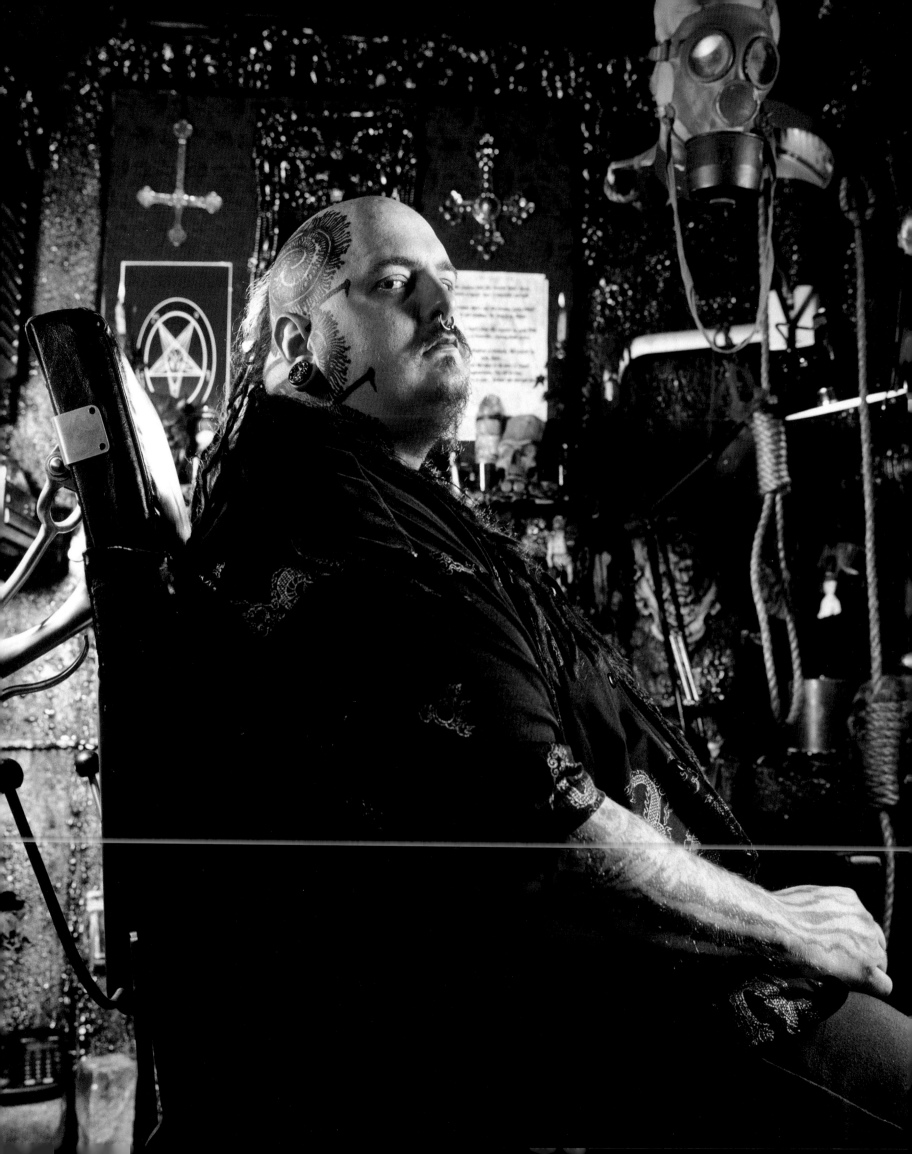

Paul Booth

TATTOO ARTIST

Why such dark imagery?
I went to Catholic school and was thoroughly poisoned by it. I have a serious chip on my shoulder when it comes to organized religion because of it. It reflects itself in my artwork.

What attracts you to metal?
The aggression. It's a venting. There's a certain sanctuary in music or art that creates a place to go in your head for the things that make you want to become a serial killer. My art has become a release both for me and for my customer. We share a dark outlook on humanity. I have to produce my art just to stay sane. My images are aggressive, very strong, dark, emotional, all things that I also find in metal. When I tattoo people who share a similar philosophy, it's always the most fun, because the collaboration is like creating a monster.

Do you consider it a compliment when people allow you to freestyle?
Fully, because I make a point of not forgetting the heavy trip that's involved. For somebody to sit there and say, "Do whatever you want; I don't care what it is," you can't take that sort of thing lightly. He's ready to wear it for the rest of his life whatever it is, no matter how good or bad it is. I'm fortunate that I get a lot of people like that, who have enough trust to let me do what I want on them. I do a lot of back-pieces and sleeves where people come in and say, "I don't care what you want to do, just make it sick," or "I want something with a witch." I kind of feel them out, talk to them a bit, get a feel for what kind of person they are, look at their other tattoos and see where they're at. I catch a vibe just sitting with them. And that vibe materializes into an image in my head as I'm drawing. So it's kind of like a recycling process.

Why do you use a freestyle method of tattooing?
When you have a direction, it's like a jail cell. I prefer not to have a plan because a plan is something you come up with when you're in that left-brain mentality. You make a plan to attack something, and it becomes very linear. And linear thinking is a direct contradiction to creative thinking. Right-brain thinking is lateral. I'm a lateral thinker, which means that I'm an airhead, space cadet, forgetful. Creation comes from my right brain, which requires lateral thought, which requires no plan.

What was the first tattoo you got?
When my daughter was born, I got her name on my arm, with a heart and a rose – it's a real typical Jersey-boy first tattoo.

Left to right:
Howie Dorough,
Nick Carter,
Kevin Richardson,
Brian Littrell,
A.J. McLean

JUSTIN
TIMBERLAKE
of 'NSYNC

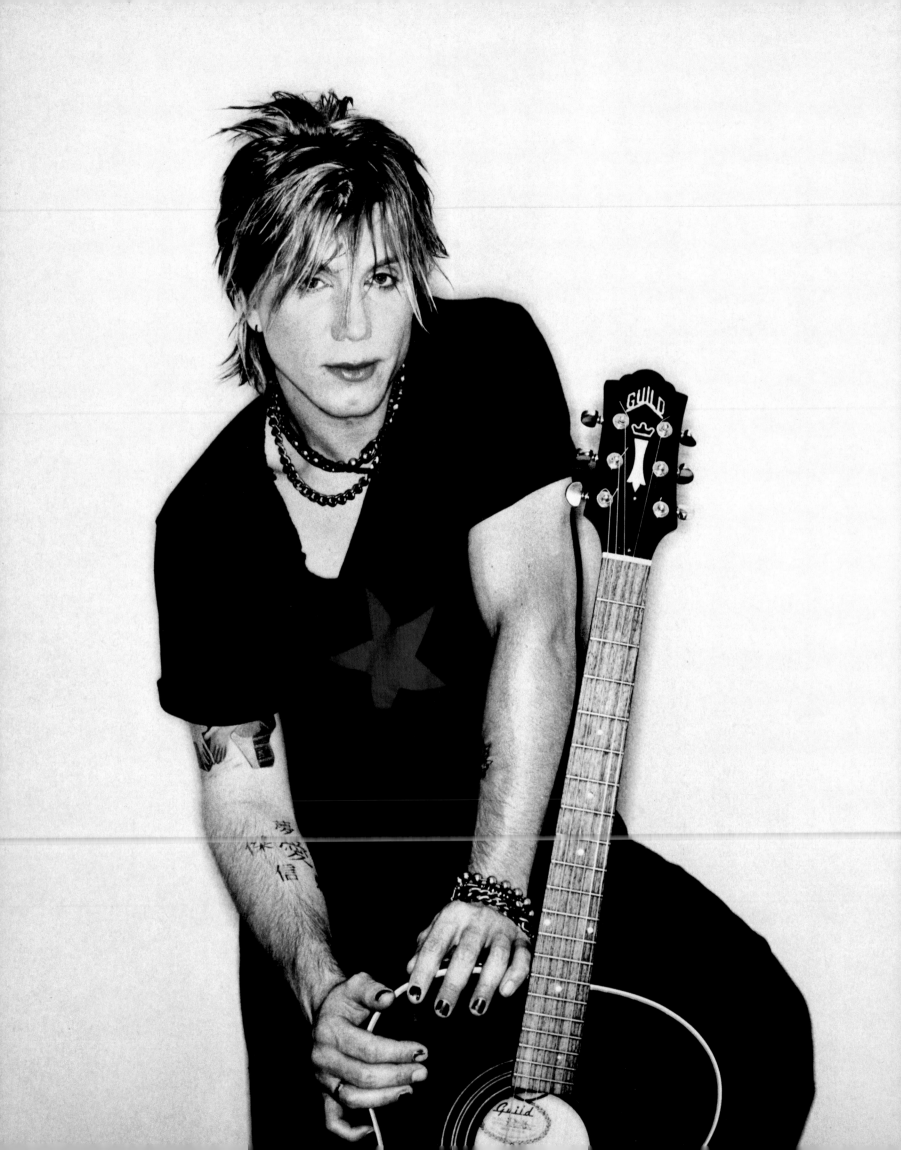

I met a girl who had a black line tattooed around her thigh, about halfway down, and above it, it said, "You Must Be This Tall to Ride."

Johnny Rzeznik

of GOO
GOO DOLLS

Jon Bon Jovi

of BON JOVI

I N 1987 I went to Sunset Strip Tattoo in Hollywood. I was originally looking to get the Bon Jovi–New Jersey logo on my arm. The tattoo artist talked me out of it – he said that any young, rebellious, true member of a biker group might look at the logo and see it as a misrepresentation of his colors. Then I saw the Superman logo on the wall of the place, and to me it signified our album *Slippery When Wet*. At the time, I was flying out over the arena crowd during our shows. Plus, we'd achieved a career milestone with the success of that record. So it made sense to me. I have covered up my tattoos many times for movies and TV. They're too recognizable. I've covered them in Japanese bathhouses too, but that's another story . . .

The bull horns – truthfully, I just ended up in the chair first when I took the Skid Row guys to the tattoo parlor! I had to get one done before the Skids would get in the chair. And I ended up getting the bull horns. I regret them in the same way your father regrets his. You get tired of them. I wish they were more interchangeable, like clothes or hairstyles.

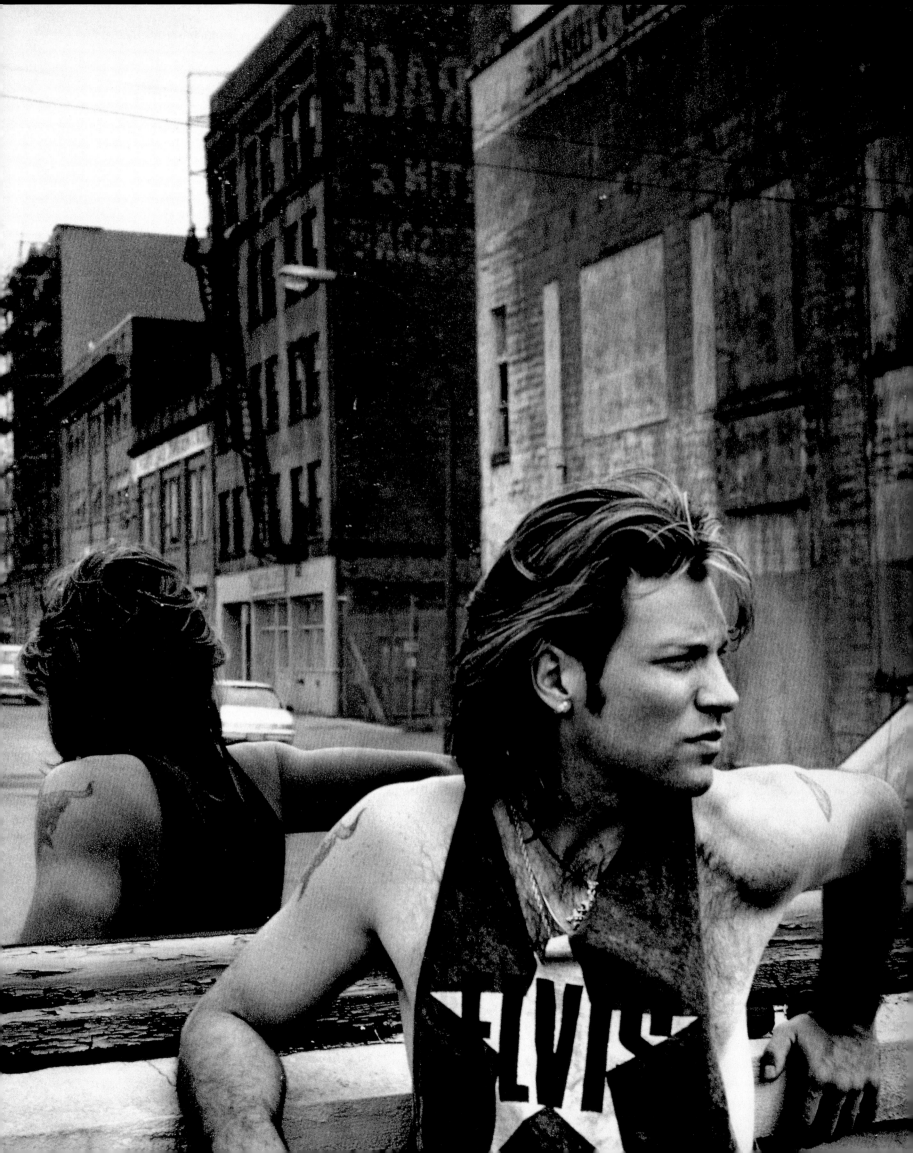

I did my first tattoo myself – it was supposed to be a band logo, but I never finished it. I wanted to remove it after a month because it was ugly and I looked like a convict. Someone said I should get a wet towel, sprinkle salt on it and rub the tattoo with it. Which turned out to be a pretty cruel joke, because all I did was sit there grinding fucking salt into this tattoo, which hurt like hell and only made it brighter.

—Dave Grohl of FOO FIGHTERS

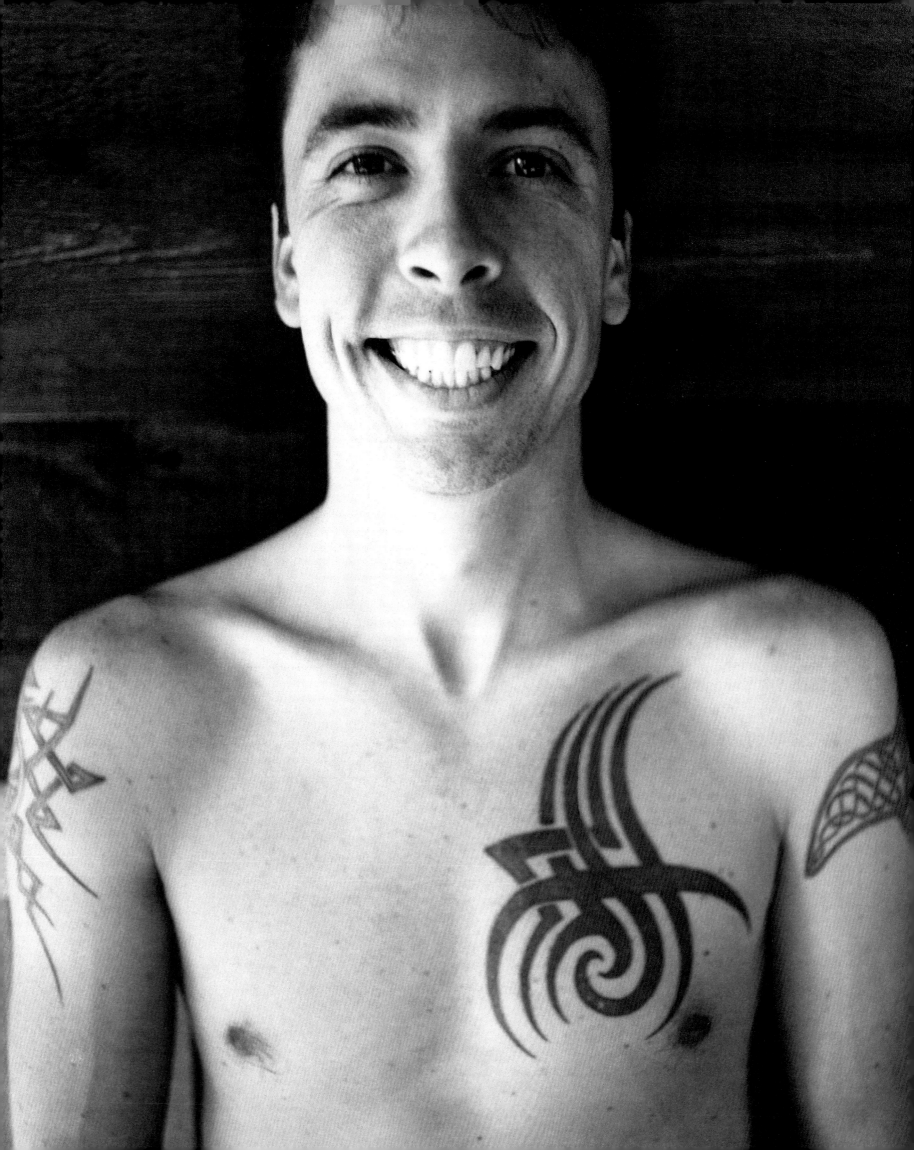

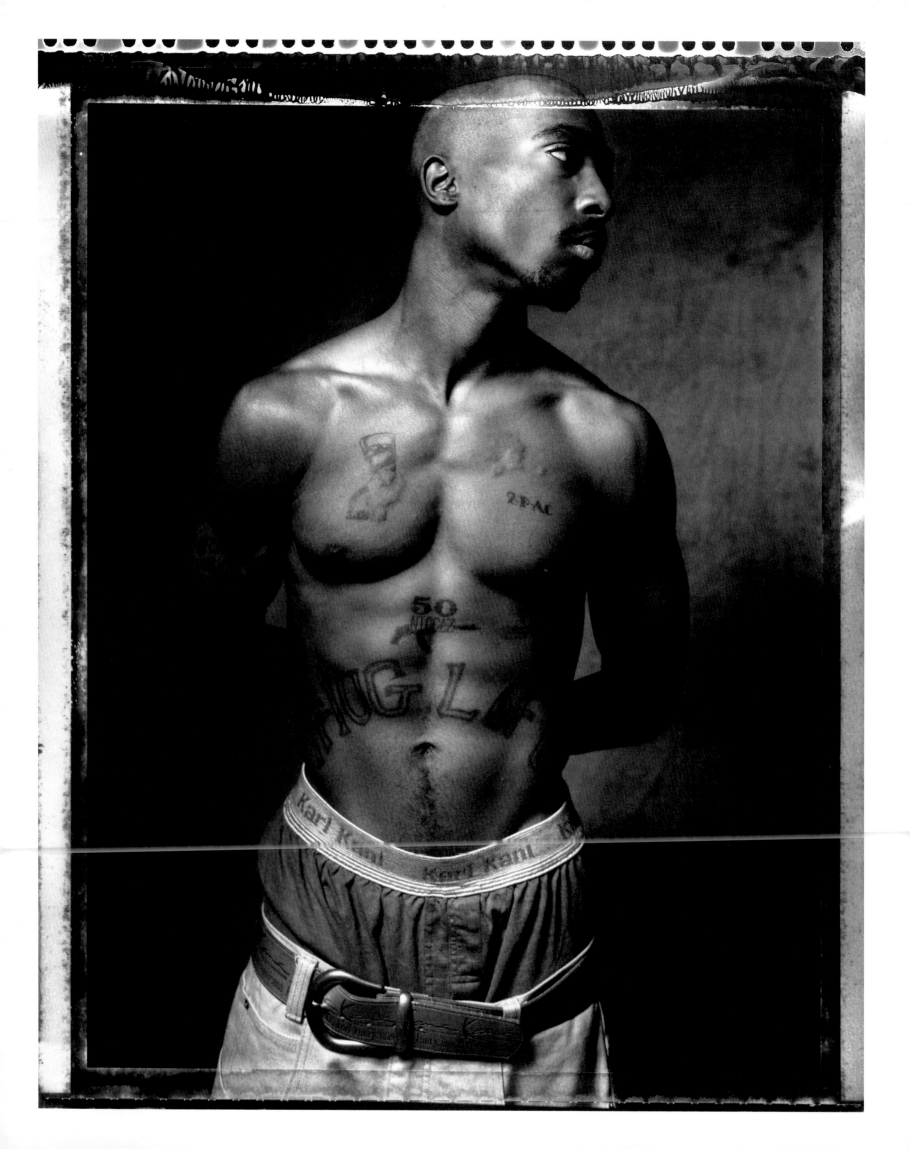

This "Thug Life" stuff, it was just ignorance. My intentions were always in the right place. I never killed anybody, I never raped anybody, I never committed no crimes that weren't honorable — that weren't to defend myself. So that's what I'm going to show them. I'm going to show my true intentions and my true heart. I'm going to show them the man that my mother raised. I'm going to make them all proud. —Tupac Shakur

Carson Daly

I GOT IT on September 13. I want to say I got it on the twelfth, but I don't think anyone went anywhere that day. But on the thirteenth, I went in to work – we were going to attempt to put on a show, but I think the bridges and tunnels were still shut, so our crew couldn't get in. Then we got a bomb threat at the building, and everyone had to evacuate. So I found myself just walking the streets around Times Square. A friend of mine has a tattoo shop up there – he's the one who did the "JD" on my arm, for my dad, James Daly, who died. So I went in just to hang out and listen to music. It's like going to a shrink for me. And he was drawing up different things, and I just thought that I might as well get something done, since the shop was empty anyway. He drew up this "NYC" with red, white and blue in it, and I was feeling pretty patriotic, so we put it on. I wasn't going to get a flag or "9/11" – it was so new. I didn't get it just because of 9/11, but when I look at it now the whole thing does kind of come back to me: It reminds me that I was here in Manhattan when it happened, that I saw the second plane hit the tower from my balcony – actually fly into the tower – and it just reminds me of being a New Yorker while everything was happening.

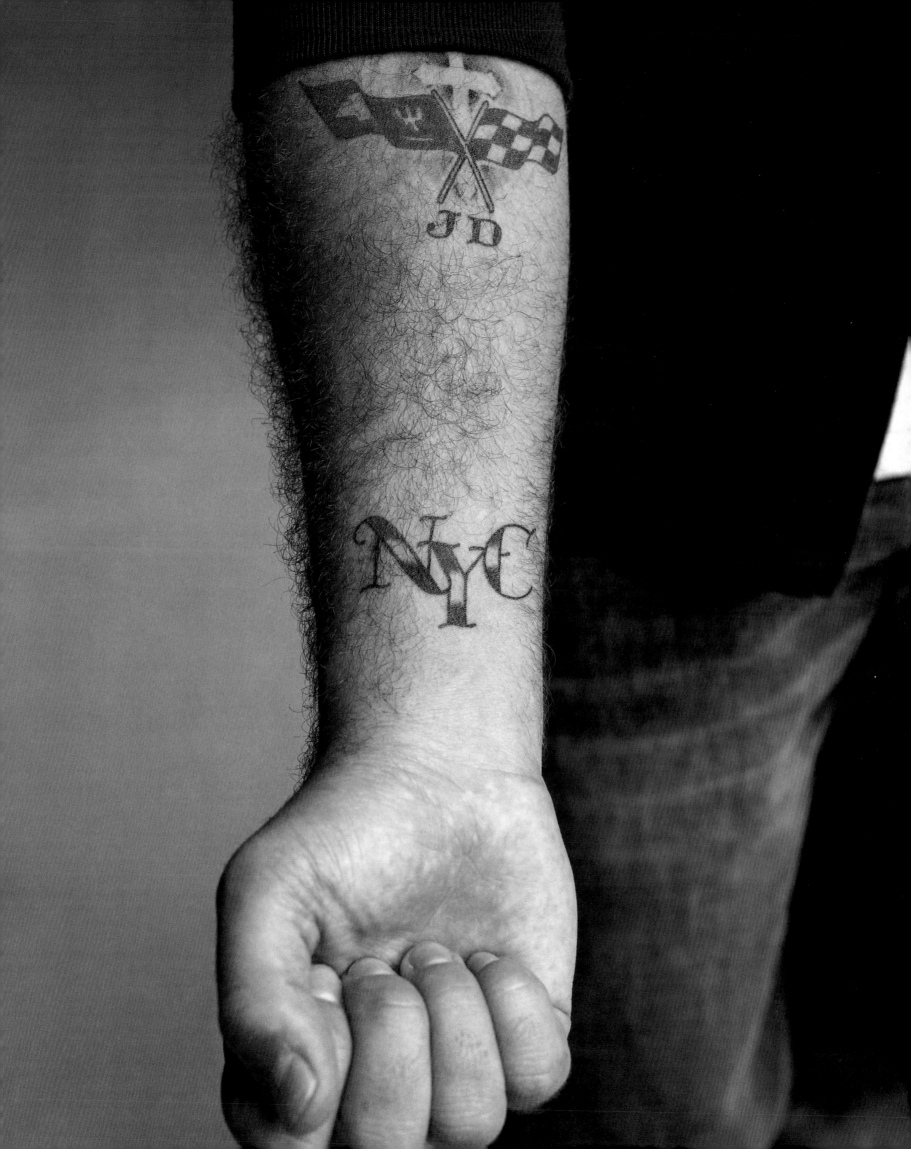

8 Ball

of 8 BALL
& MJG

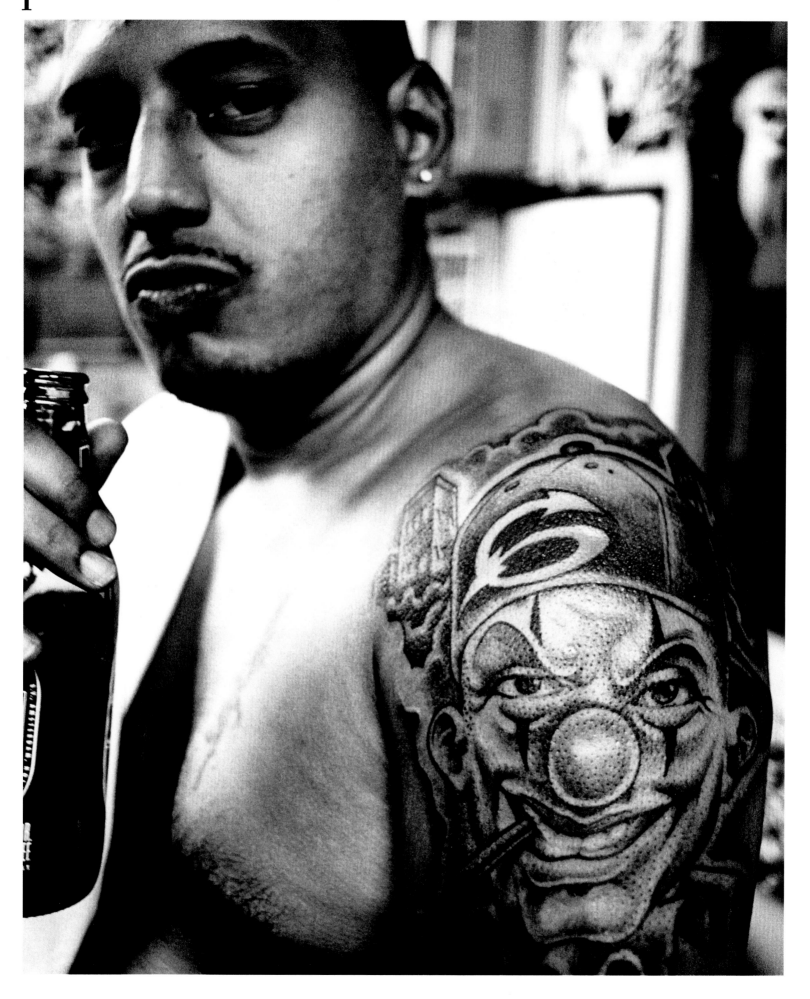

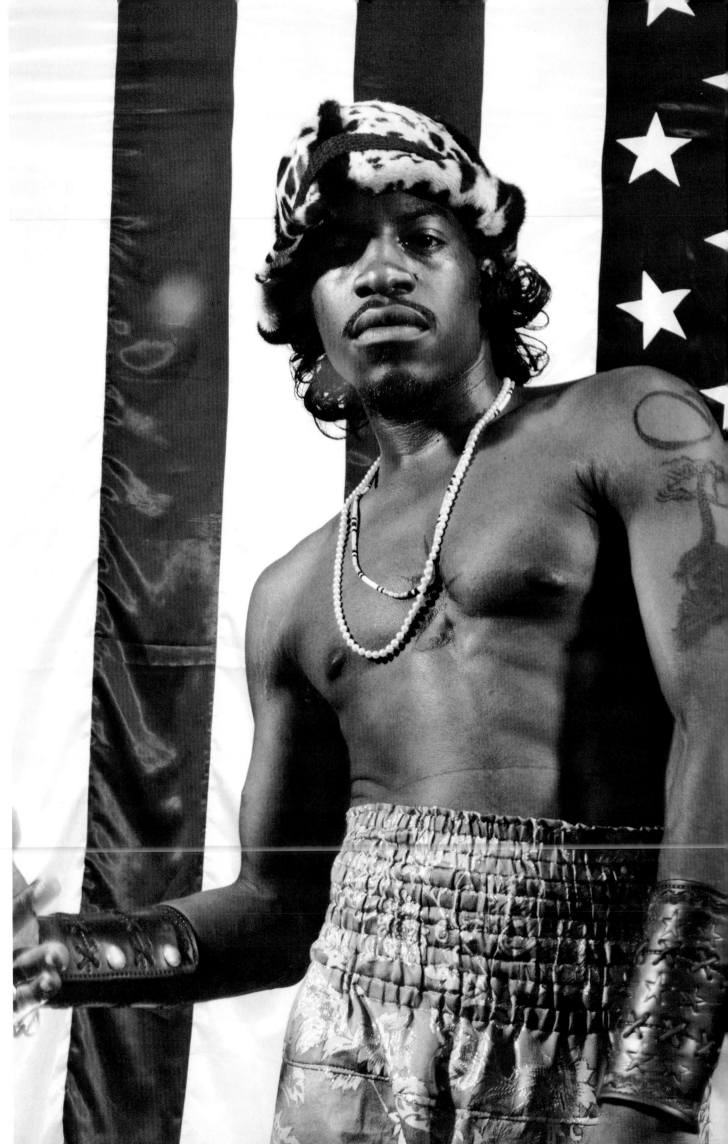

I just
don't
like
looking
like a
clone,
man.
–André
3000

André
3000 (left)
& Big Boi

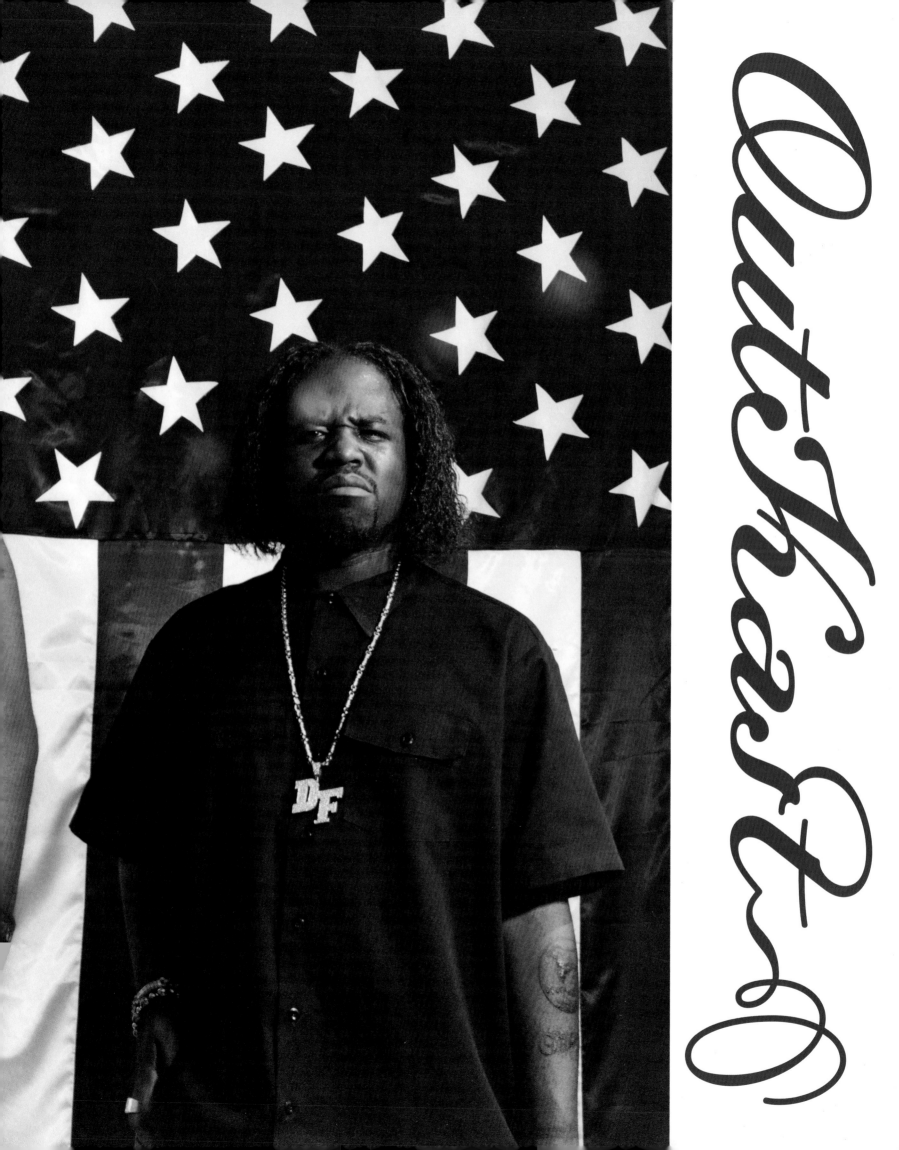

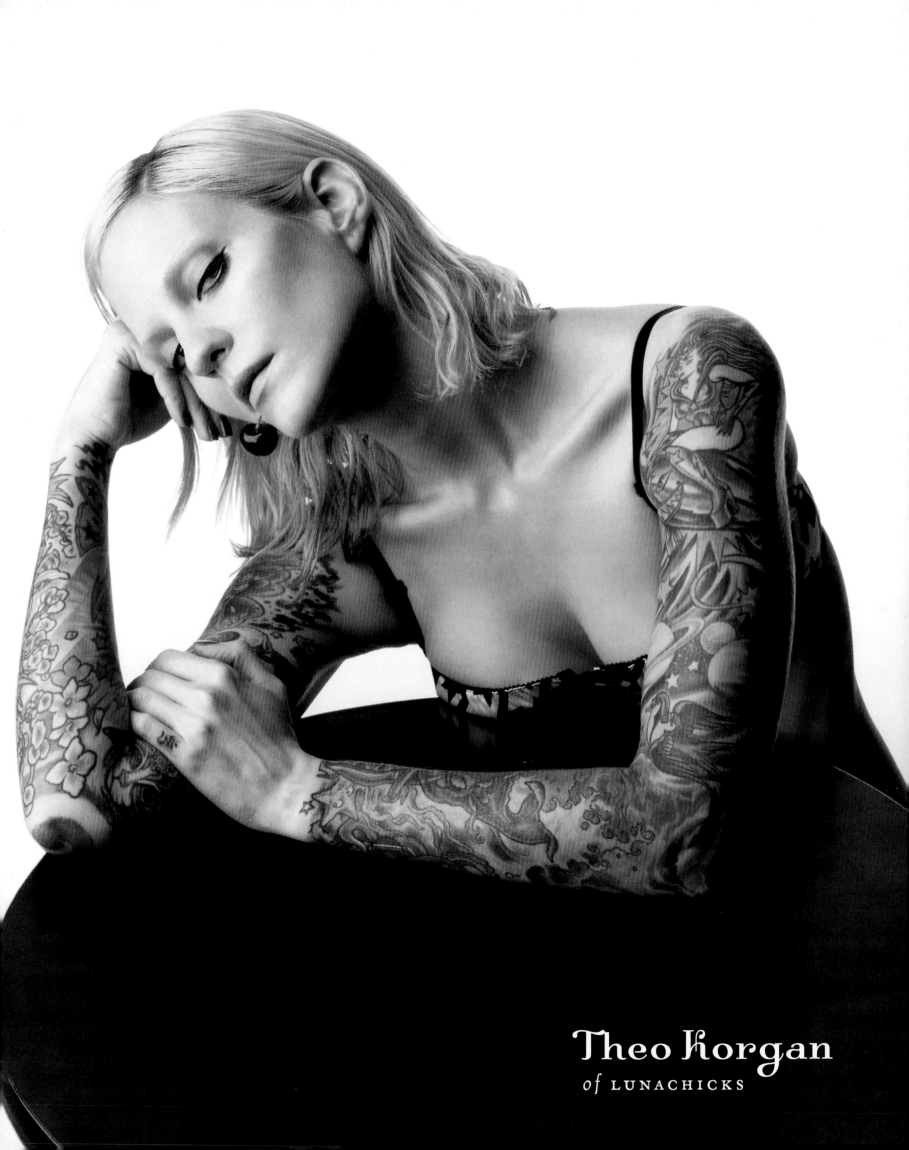

Theo Korgan
of LUNACHICKS

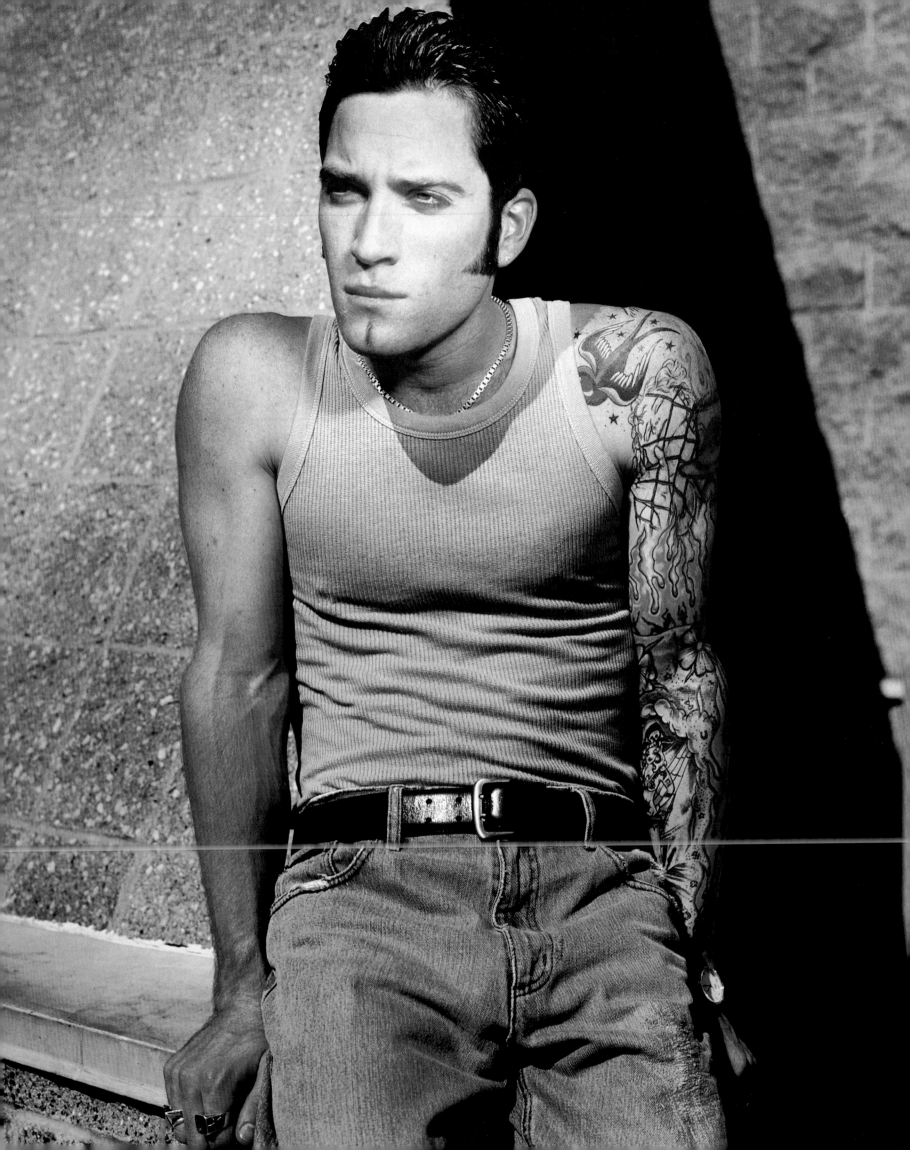

A. Jay Popoff

of LIT

I GOT MY FIRST TATTOO when I was seventeen or eighteen. It's the one on my leg – a friend of mine did it on the pool table in my parents' house. Back then, I didn't have money to pay the good artists, so all my tattoos were done by people I knew. But I was hooked once I got the first one, just like everyone says. I like getting tattoos for a whole combination of reasons. It's the pain, a little, but it's also the sound of the tattoo gun, and the smell of the green soap they use, and the atmosphere of the tattoo shop, with music playing – almost always it's AC/DC or maybe Social Distortion or something of that sort – and other people getting tattoos. To me it's just the epitome of rock & roll. When one of my friends gets one, I'll stop by the tattoo shop to check it out, and that's when it's time for me to get another. I can't watch someone get one without getting one.

* * * * *

THE SLEEVE on my left arm isn't really an overall picture. It's more of a style. I'm into the sailor-style tattoos – the old school from the Thirties and Forties. Very simple and traditional. I have a sailor-girl tattoo that takes up my whole right side. What I'll do is sit down with the artist and tell him what I want, and we'll sort of build it and doctor it up together. The biggest mistake people make is over-thinking their first tattoo. They want it to symbolize something meaningful that will last forever. But you grow out of everything, so I think when it comes to tattoos you just have to find what you're into, whether it's a certain style or a concept, just like in art for your house.

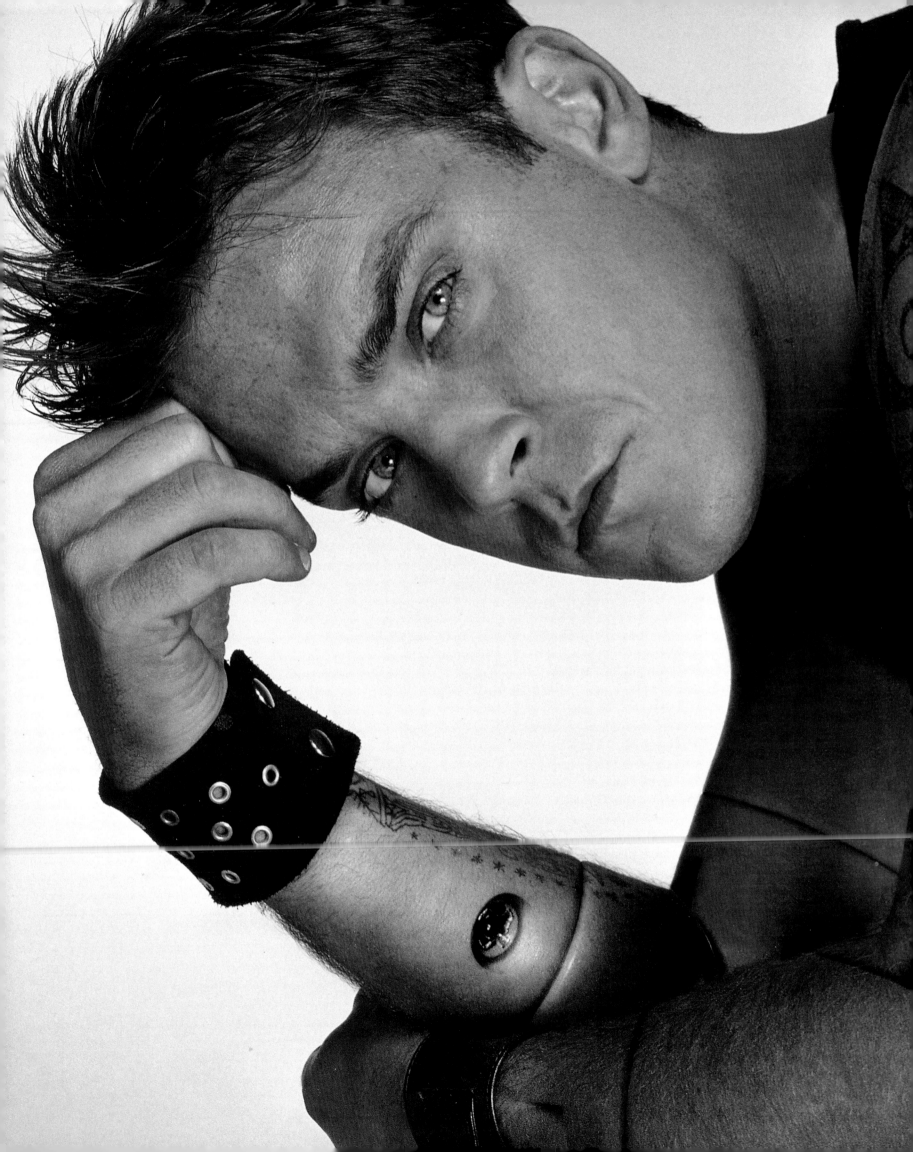

Robbie Williams

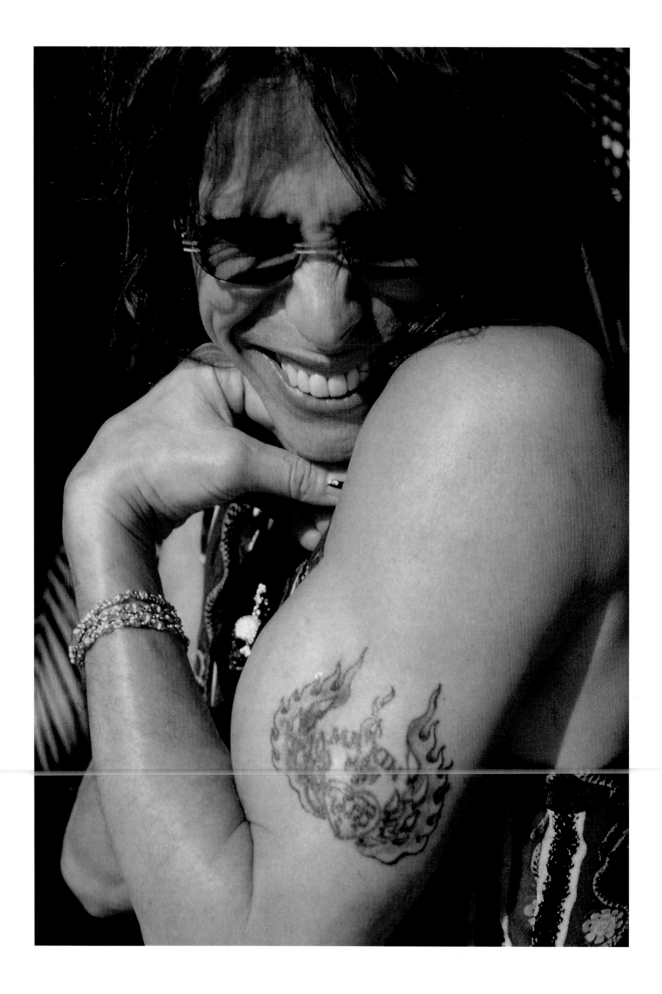

"MAMA KIN" was one of the first songs I ever wrote, and I thought it was so good, I thought for sure it was gonna be a Number One – you know, you have these delusions of grandeur when you aspire to be a rock star. I was about twenty-six, and you just want to be like Janis Joplin, like Mick Jagger, like the Animals and the Who, and you want to be chased down the street like in *A Hard Day's Night*. Anyway, I went into a tattoo parlor, and they had all those pictures on the wall – you know how you look through the books and see what they've done to millions of people – and I said, "Forget about it. Just put 'Mama Kin,' and let's do some flames like this, and put a heart like that, and do the colors . . ."

Were you the only one in the band with a tattoo?
No, Tom got one; he's had it burned off. Wuss. Joey had one on his arm, and since then he's had it burned off. But you know, therein lies the difference between two people. It was something – it's like burning all the pictures of you as a child. I don't get it. But that's how they think.

It's still a part of your life that you once felt so strongly about.
Right, and you'll always look down and see it and say, "God, I remember when we got that, and it meant something." Obviously, to them it doesn't mean anything, so . . .

Why do you think musicians get tattoos?
I think it has to do with honoring the part of you that knows – how can I say this? I think your average person doesn't know that he's a precious child of God, an offspring of something that's not of this planet.

You know, if you really think about it, we're the aliens here. I think we're unlike any other animal that's indigenous to this planet. You know what I'm saying?

No.
Well, that every other animal – we may think that it cries and thinks and has afterthoughts, but they really don't, they don't put . . . [sighs]

How did getting the tattoo make you feel?
I can't tell you, it was so sexy for me to get one on my arm. Every time I got out of the shower and I looked at that on my arm – it must be like when a girl is nine and she starts growing breasts, and the difference between nine and fourteen, and every time she looks at herself naked she sees these breasts, these beautiful breasts that she grew, and it's just, it's like, "Uh, look at those!" Because they grew out of a flat chest! You know what I mean? It's kind of like, a man is born with a penis, but imagine if he was nine and it just grew then. It would be like a tattoo. One day you don't have it, the next day you do.

So what does "Mama Kin" mean to you now when you look at it?
It means that I meant what I felt back then. I thought it was a song, and even though it wasn't a single, it was still one of the first songs I wrote, and it means that I'm about song, and I'm about fantasy, and I'm about dreams coming true. I'm a living example of, you know, be careful what you wish for. I may be a rock star, but only because I willed it and I wished it and I had some good luck. Most people don't understand that. They don't understand that you can be whatever the fuck you want to be.

Steven Tyler

of AEROSMITH

I GOT MY FIRST TATTOO about four months ago. All through the Seventies and Eighties tattoos were so trendy, and unless it really meant something to me I wasn't going to get one. I made the decision to get mine because my wife has one on her; she's had a tattoo since she was seventeen, I think – we've been married almost eighteen years, and she added my name on her tattoo seven or eight years ago.

* * * * *

MY TATTOO is basically the cross that you find in a lot of religions and an open eye, like being open to the crossroads, and around that the astrological symbols of my wife and kids. We have four kids – I'm a Virgo, she's Aquarius and so is one of my sons, and we have a Capricorn and two Libras, so they're all surrounding the eye.

I think on a lot of levels we're always at a crossroads. Whether you're literally at an intersection trying to make a decision about which way to go, or you're making a business decision or a decision about your love life or your family, there are a lot of crossroads where you have to have your eye open and be sure you're making the right decision.

WE'VE BASICALLY SAID to our kids, you guys have gotta get a little bit older before you do it. They haven't really asked yet, but my ten-year-old went through a period where he wanted to get his ear pierced – for about five minutes. They're into coloring their hair and things like that; we're pretty open and free with them. We let 'em know that we gotta talk about it if they wanna do something, and they're pretty cool about that stuff. The kids were in the room while I did it. They kept going, "Does it hurt, does it hurt?" and I kept going, "Yes, yes." It's like with anything else that's big and dangerous that fascinates kids. It's like with guns – you teach them how powerful and dangerous it is, that it's not like in the movies, and suddenly it loses its mystique.

My wife loves the tattoo. I think she's always liked the idea of me getting one – she thinks it's butch, and she likes that. She said she was "happy and sad," because she loved my arm just the way it was, untattooed, but hey, it's her name on there. And it's like when we fight and we're naked, we still have the tattoos, so you can't really deny that.

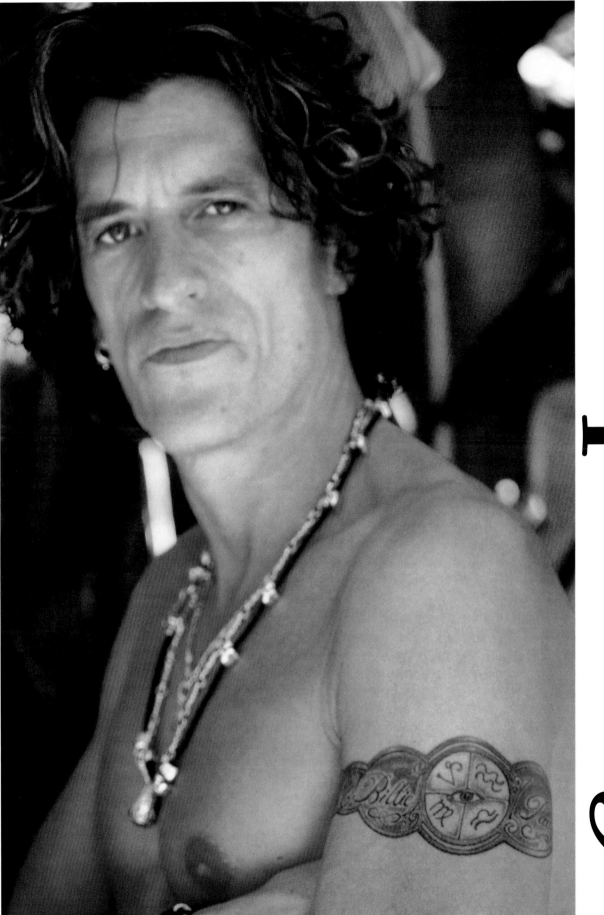

Joe Perry

of AEROSMITH

SCOTT
WEILAND
of
STONE
TEMPLE
PILOTS

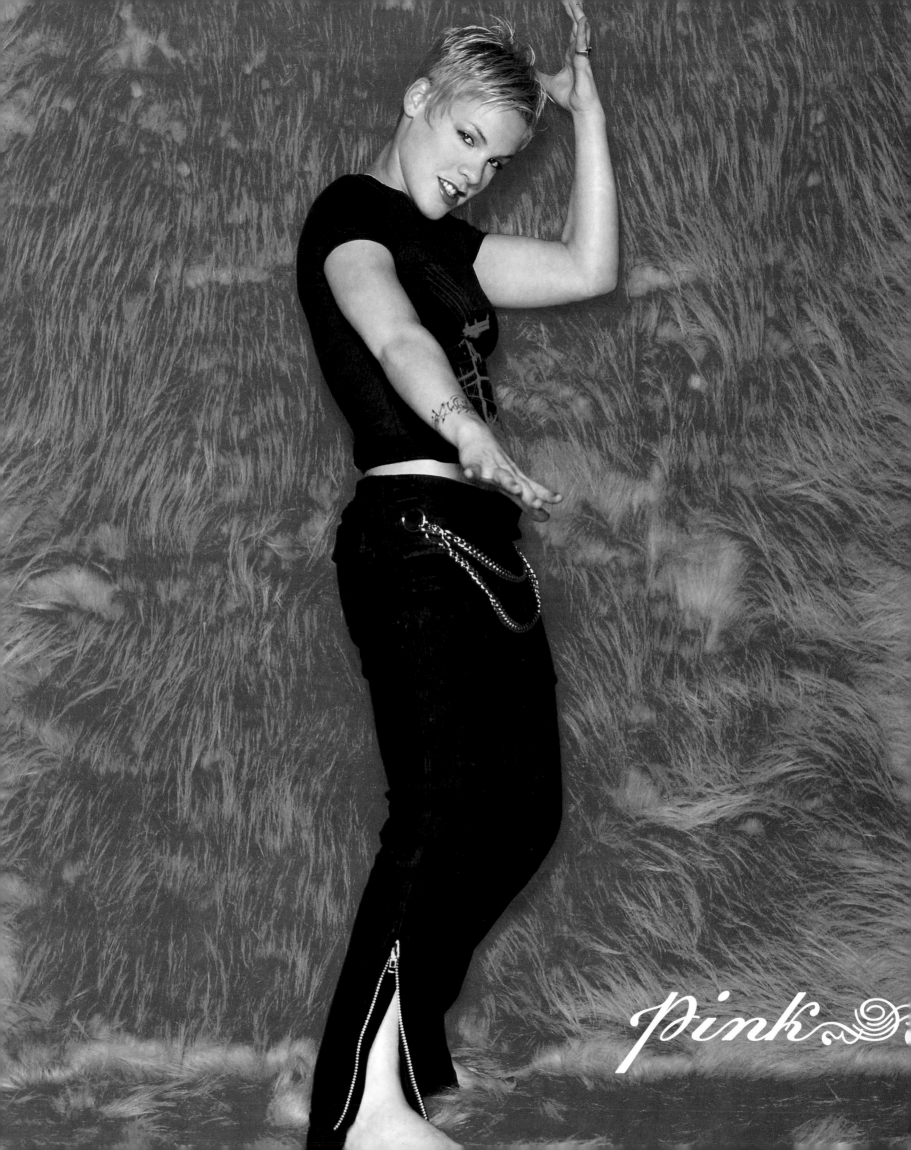

Pink

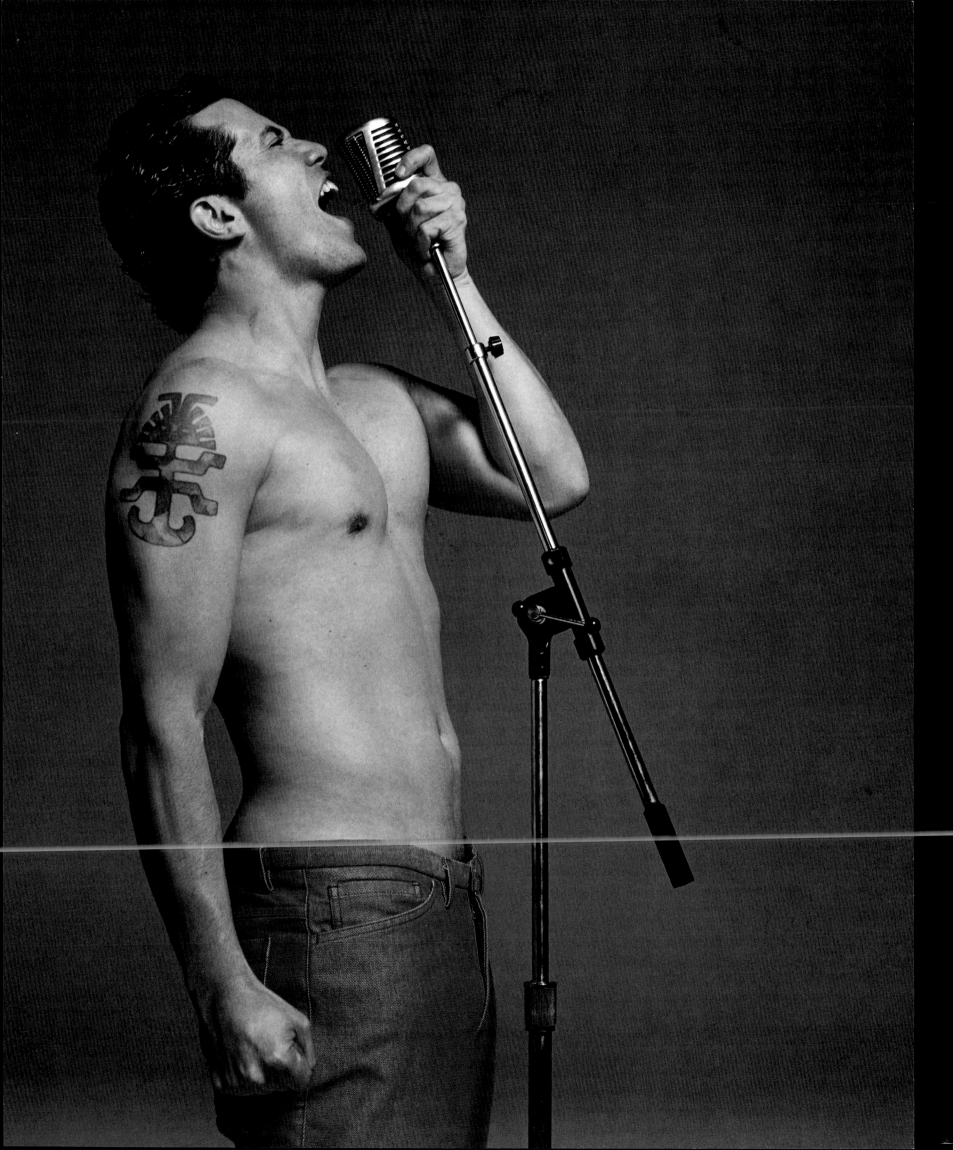

I broke up with a girlfriend and got a tattoo of a flaming heart with a knife through it. But it was too small—people kept asking if it was fake. So I decided to get something bigger done on top of it. I picked an Incan symbol, because my mom is part Inca. It's a dancing warrior, an entertainer who's still a fighter. I like that idea.

John Leguizamo

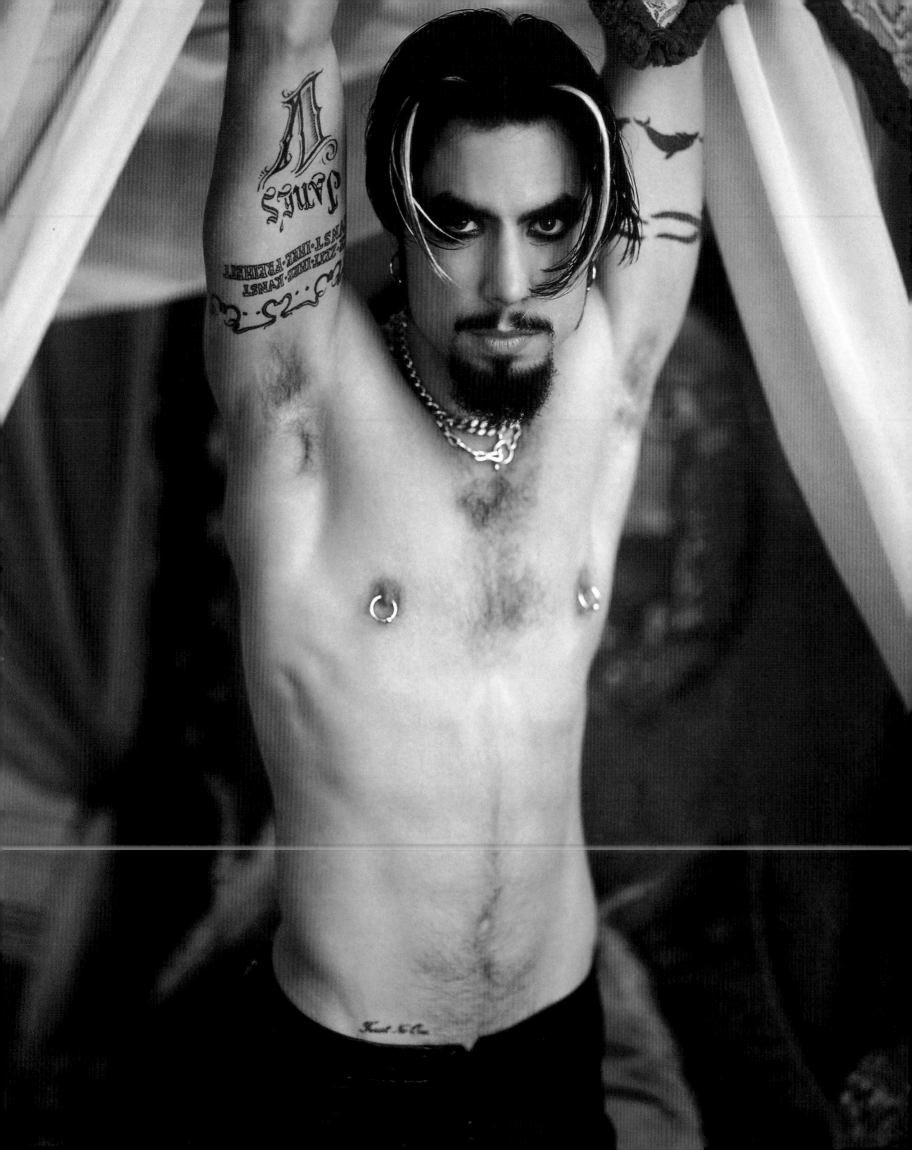

Dave Navarro

I GOT MY FIRST TATTOO when I was seventeen, a picture of a pig on my left shoulder. I was hanging out with Eric Avery from Jane's Addiction, and we were just kind of talking about tattoos. Neither one of us had one, so we thought it would be fun. Later that year I added a snake wrapped around the pig. The reason honestly escapes me. At the time, there's always some reason behind it, but they just kind of lose their meaning. I'm not the type of guy who makes an appointment and draws up ideas. I'm just into the instant gratification. I do it because it's fun to do. At this point, I have so many tattoos that removal by laser surgery is no longer an option. So when I have the inclination, or if I'm near a tattoo parlor, I'll pop in, see who's working and maybe think something up there. Or I'll have a couple ideas on file. And I just do it. My body just has become a diary. I'm not going to have things removed or covered up. I can't change my nose unless I go and have surgery, and the same goes for my tattoos. I can't deny the moment that the tattoo came from – it did hap-

pen; it was true and valid. I used to be of the mind-set where every one had to be deep and powerful. But life is way too short to give that much power to something as trivial as a tattoo. Ultimately, if it's not fun, and it's not something you enjoy, then there's no point. In two years I've changed my thinking from trying to do something deep and artistic to just trying to do something I enjoy.

Of course, I've thought about them all. I'm not going to go out and get a flying toaster. One thing I really like about tattoos is that they used to be a way to keep people away from you, and now they're a way to invite people in. Questions like "Did that hurt?" and "What does that mean?" become very common after a while. I usually just tell people I got everything done in jail. "That was from when I was in San Quentin."

I have two Gustav Klimt paintings as tattoos, one on each forearm. One is called *Hope,* and it's a picture of a pregnant woman. It's kind of an homage to my mom, who died when I was fifteen. And the other one is called *Death and Life,* which is kind of a Grim Reaper image –

it's only part of the painting – which is located on the opposite arm in the same place. So it's kind of like one is a life figure and the other is a death figure. I also have my mom's name, "Constance," across my lower back. I have relationship-oriented tattoos, but for the most part they're symbols, not names. The most obvious one is that I have my fiancée Carmen Electra's initials. I have them right over my heart.

What about the two women on your lower legs?
One is a kind of dominatrix, and the other is a nun. It just worked out that way. If I were going to look for any meaning behind it, I would say the comedy-tragedy theme, or the yin and the yang, dark and light – who knows what I was thinking?

Have you ever thought about doing tattoos on anyone else?
You've seen *The Decline of Western Civilization?* I've always kind of wanted to do the needle-thread–India ink thing. But when are you ever lucky enough to just have those things lying around?

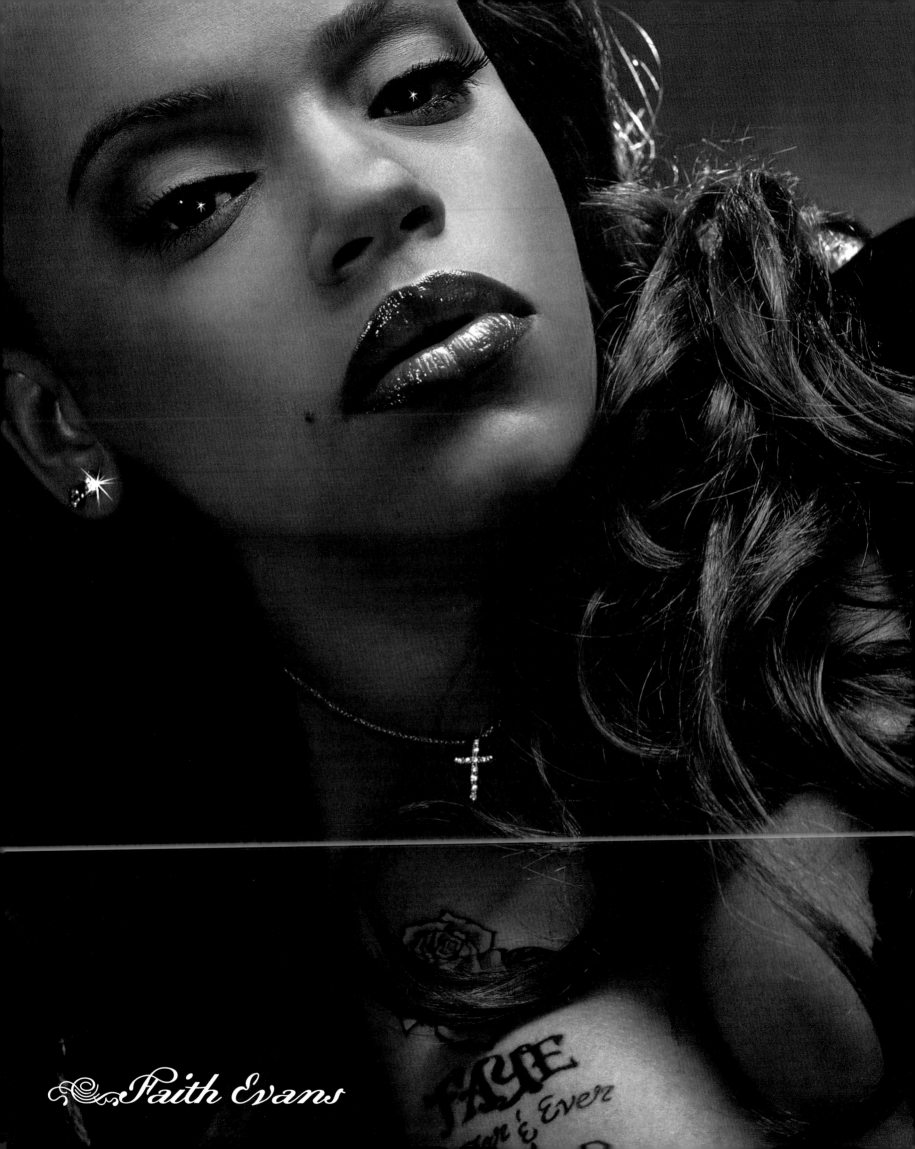

Faith Evans

Ben Harper

My body is a work in progress. I've become the Tattoo Guy. It's my obsession right now. I don't drink, I don't do drugs, I don't chase girls; I get tattoos.

—Art Alexakis

Left to right: Greg Eklund, Art Alexakis, Craig Montoya

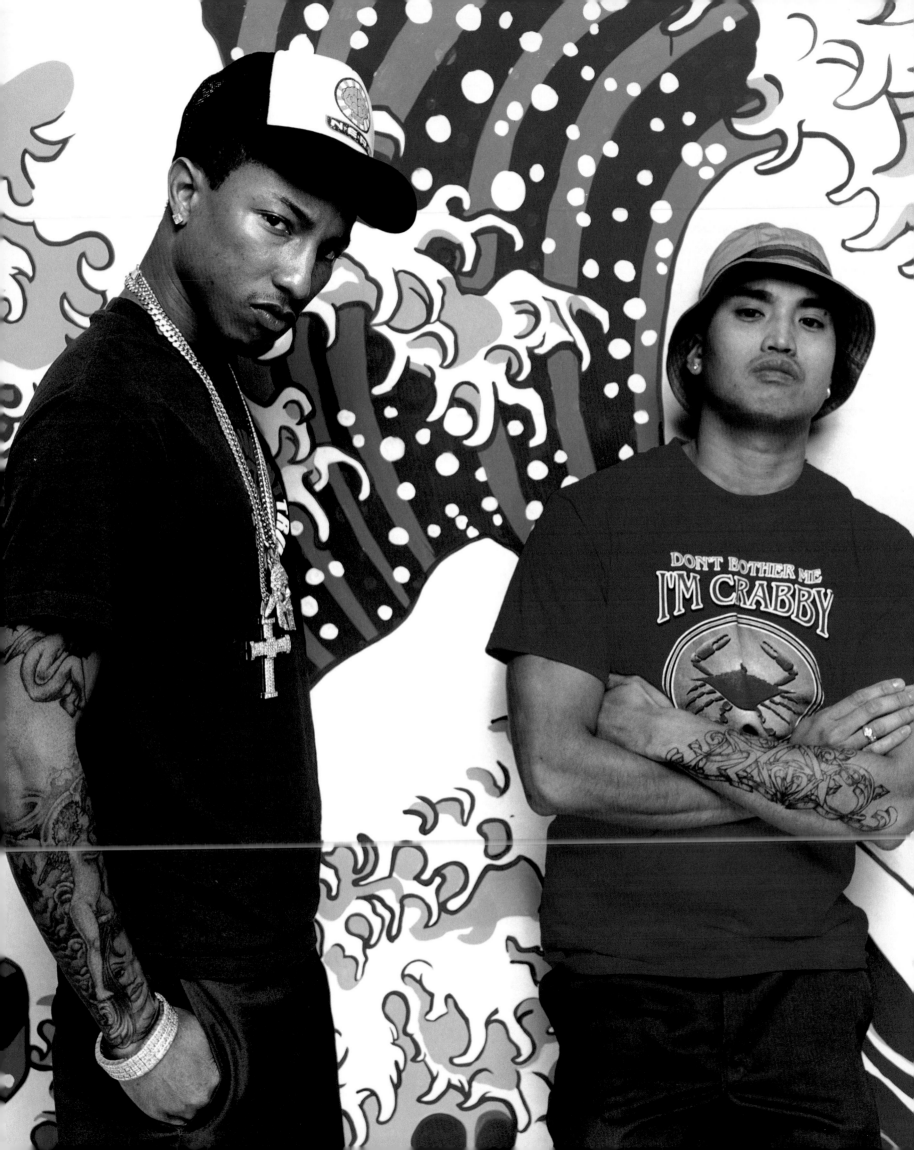

Neptunes

THEY'RE ALL ANGELS. They're protection, although they're just figurines on my arm. They're a reminder of goodness and righteousness. I try to be as good a person as I can, but it's always cool to look down and have a constant reminder of what you should be like. The world is full of so much sin. Life can be cruel, and you always need angels around you. They do God's work. I'm just exposing a really strong part of me, and I don't really want to talk about that. It's just for me. You've got to keep God first – I've always said that.

I haven't gotten one in a while, I'm probably done. Just know that it's for the rest of your life, and once the novelty wears off it's like, damn, are you really glad you got it? If I had it to do all over again, I probably wouldn't have. But I'm not bent out of shape. I can deal with angels being on my body. Do you have to do that in order to remind yourself to be cool with other people? No, you don't have to. I'm just saying that at that moment it was my justification for doing it.

– PHARRELL WILLIAMS

Pharrell Williams (left) and Chad Hugo

I got it when I went to Arizona to hang out with my godmother. It's an umbrella that signifies protection.

Maxwell

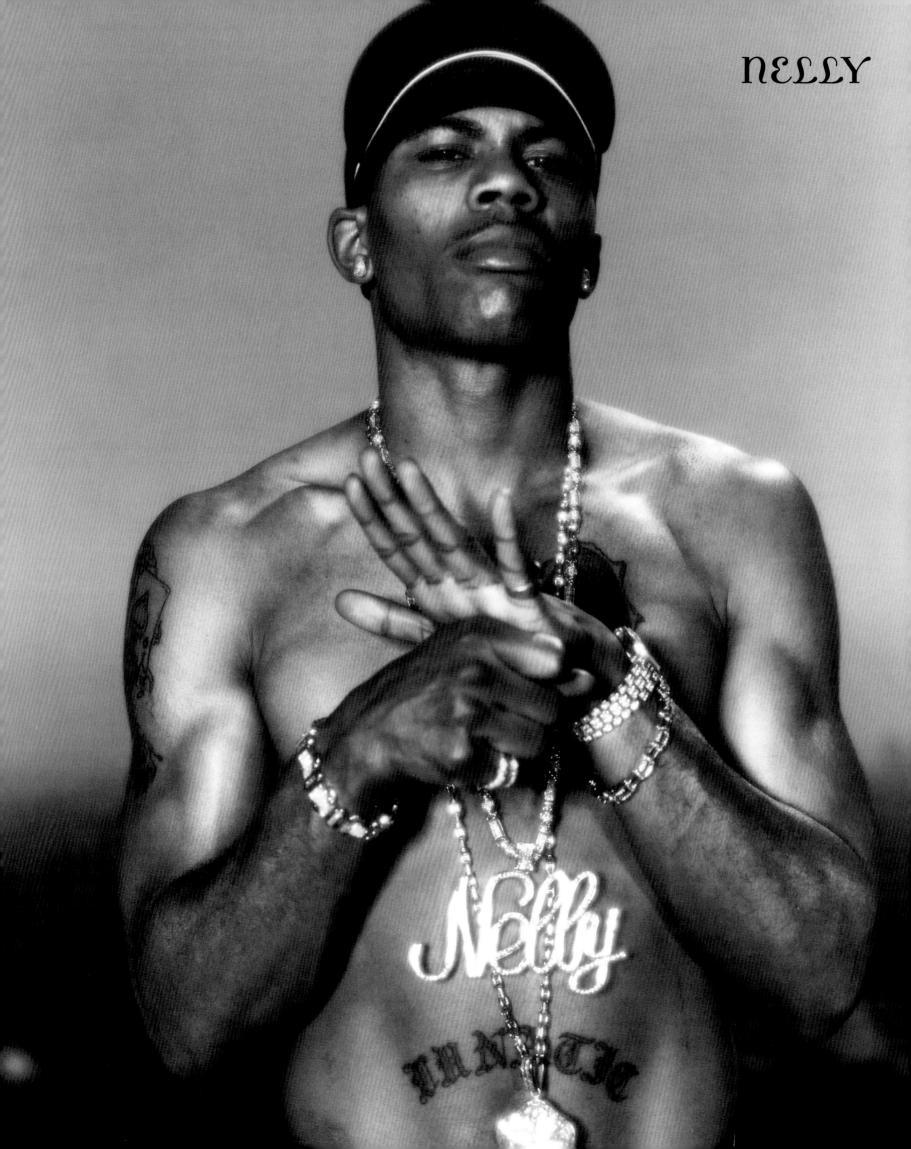

NELLY

Crazy Town

TROUBLE

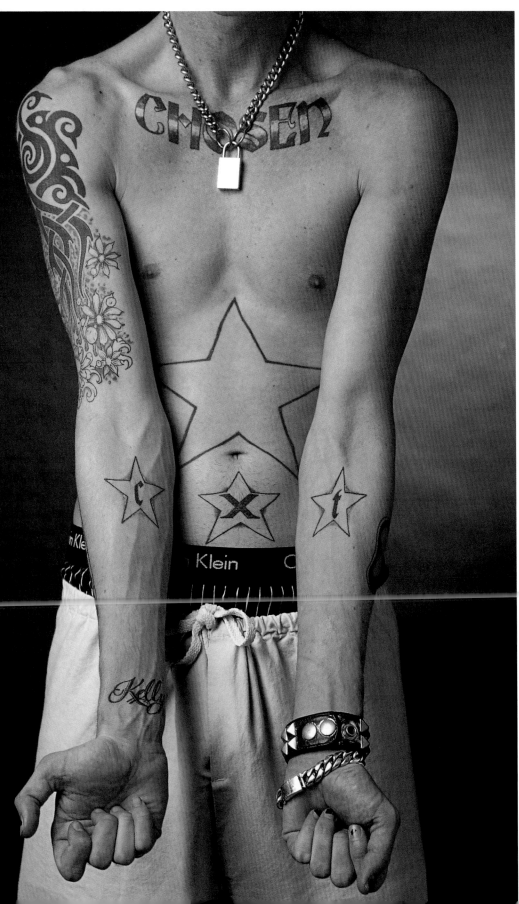

I got my first tattoo on my eighteenth birthday. It was a marijuana leaf on my right arm with a tribal band around it, because weed was the biggest part of my life at that point.

—Shifty Shellshock

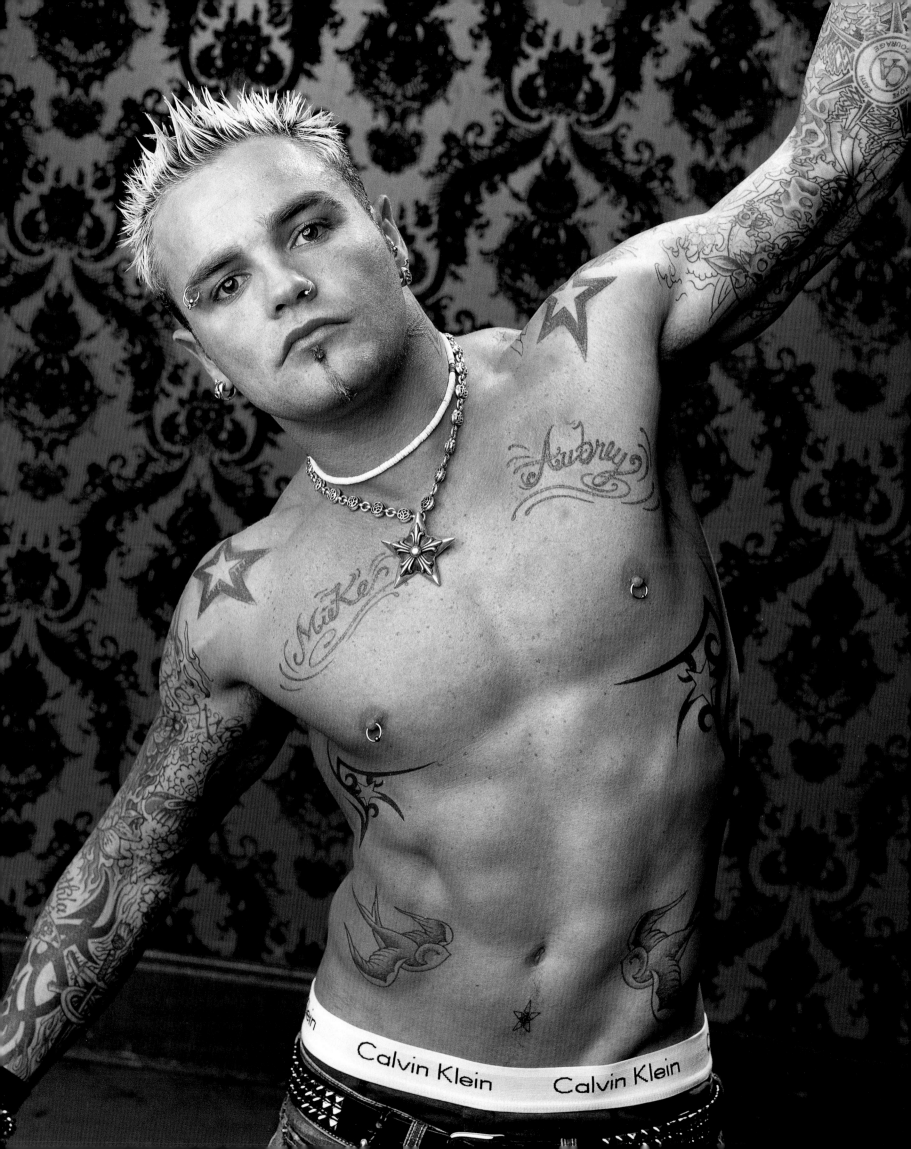

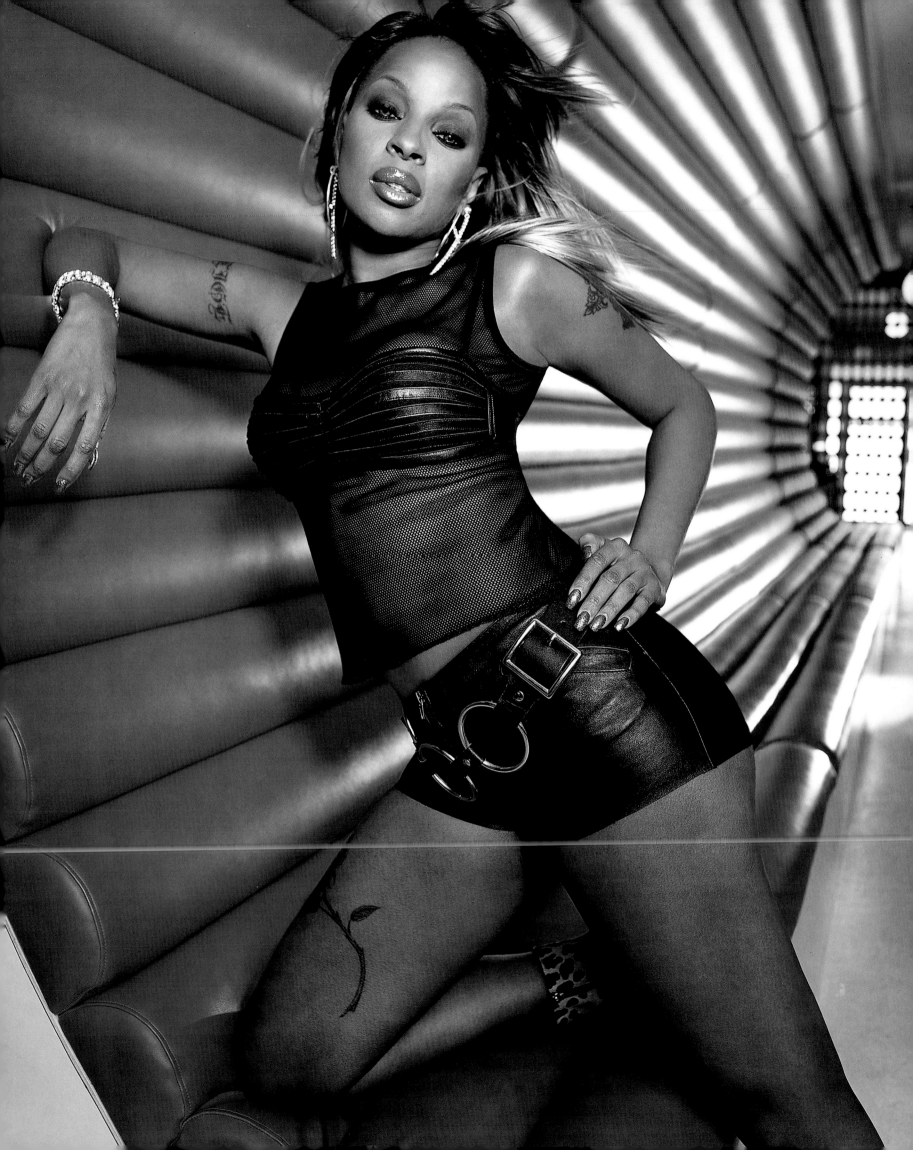

Mary J. Blige

THE MOST MEANINGFUL one to me, I think, is the soul-mates tattoo, the one that's on my back. It's two angels. They represent what I was wanting to happen, which was to find a soul mate. I got this tattoo three or four years ago. I was just willing it to me – you know what I'm saying? Like claiming it and knowing it was going to happen. I was practically single then, coming out of something, and yeah, I got that. It means a lot to me now because I'm no longer looking. I came up with it – you know how the tattoo artist opens the books and shows you stuff? This one was the perfect design, two angels kissing, and I just put a label on the bottom of it, "Soul Mates," like a girl angel and a boy angel. I like angels.

I was excited about getting my first tattoo, but I was only twelve, so I had to hide it from my mother. By the time she found out, two years later, she was more upset about the fact that I had gotten drunk and ended up getting stabbed in the leg with a bottle by one of my friends.

— MARK WAHLBERG

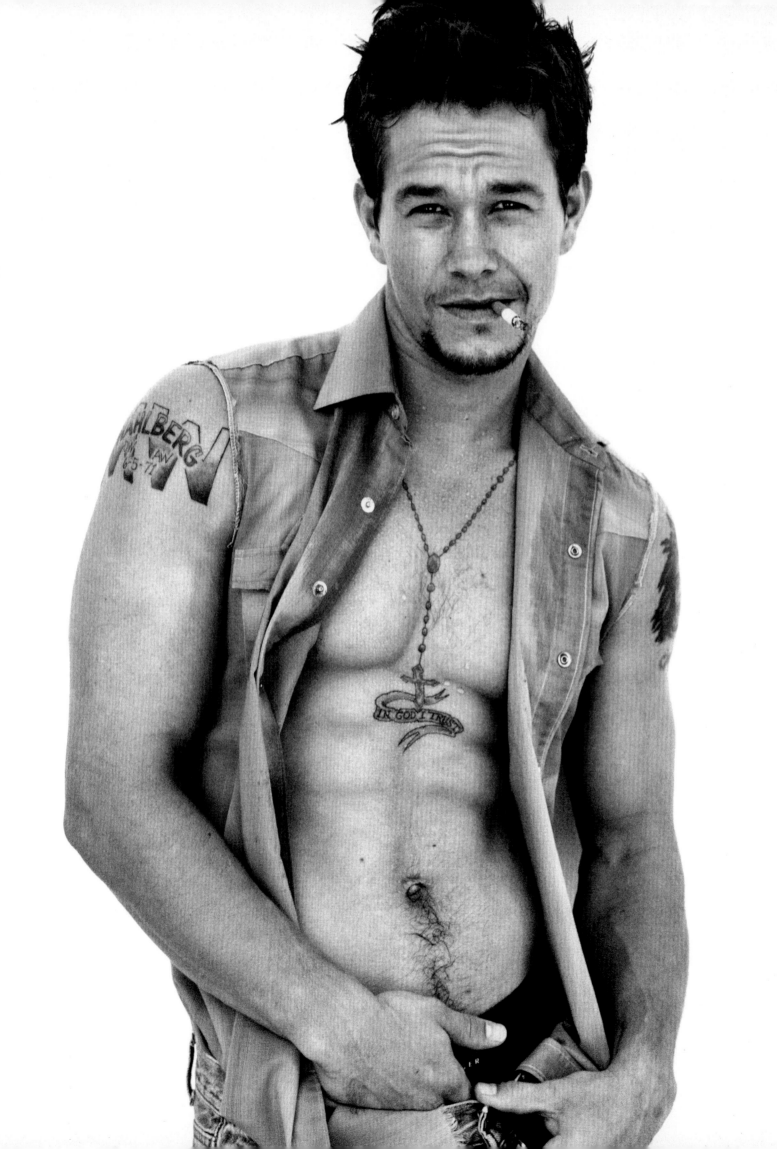

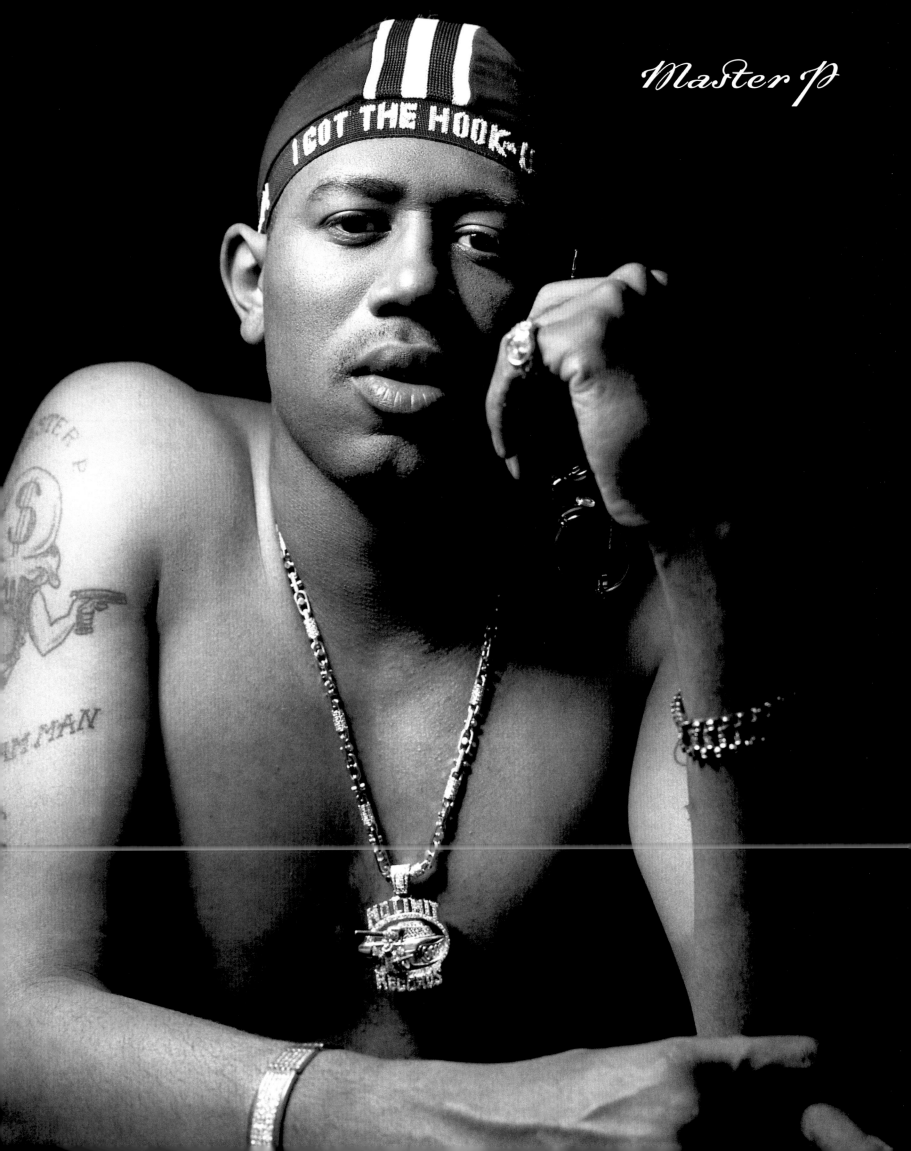

Master P

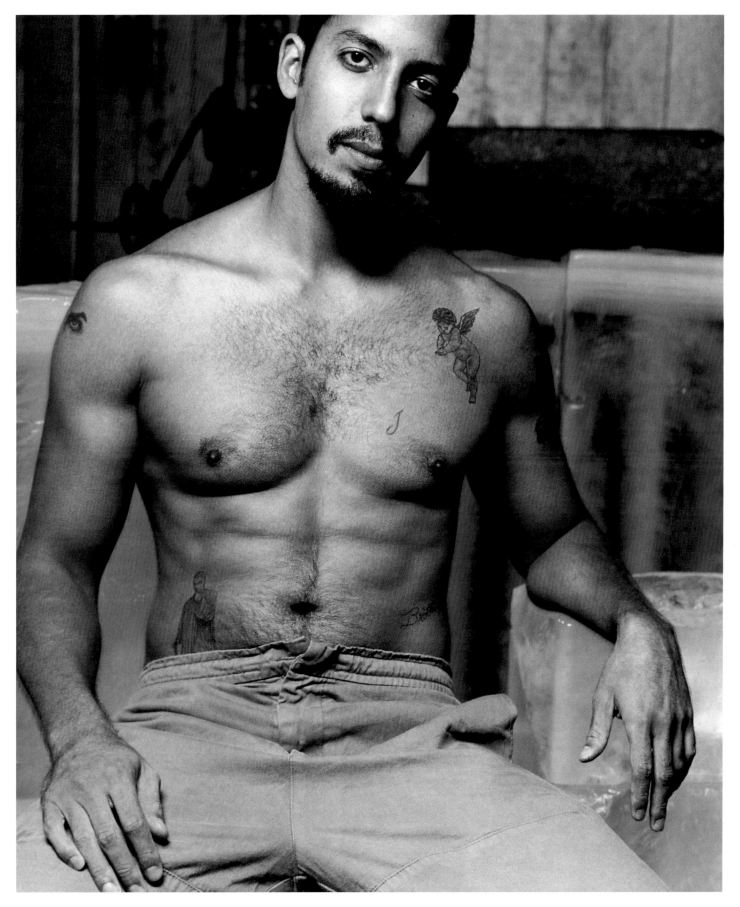

David Blaine

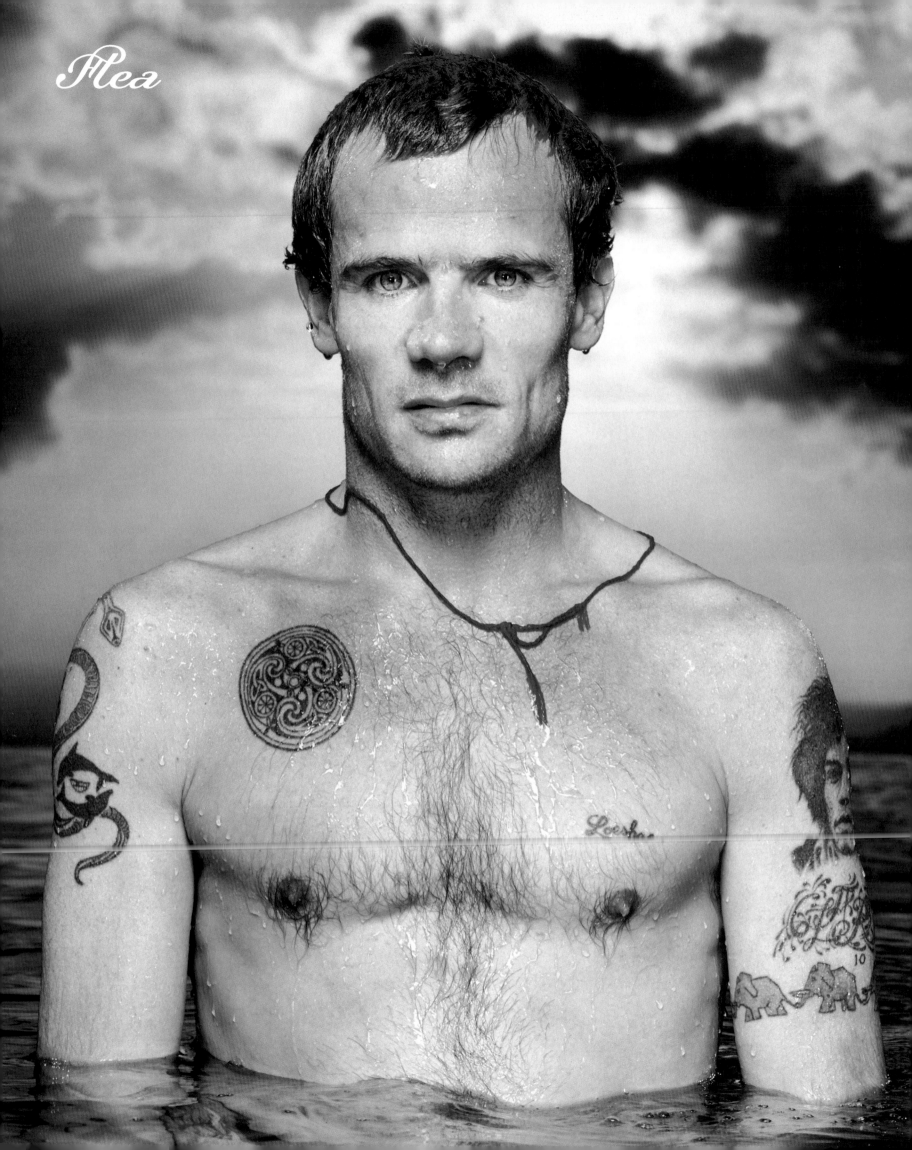

Flea

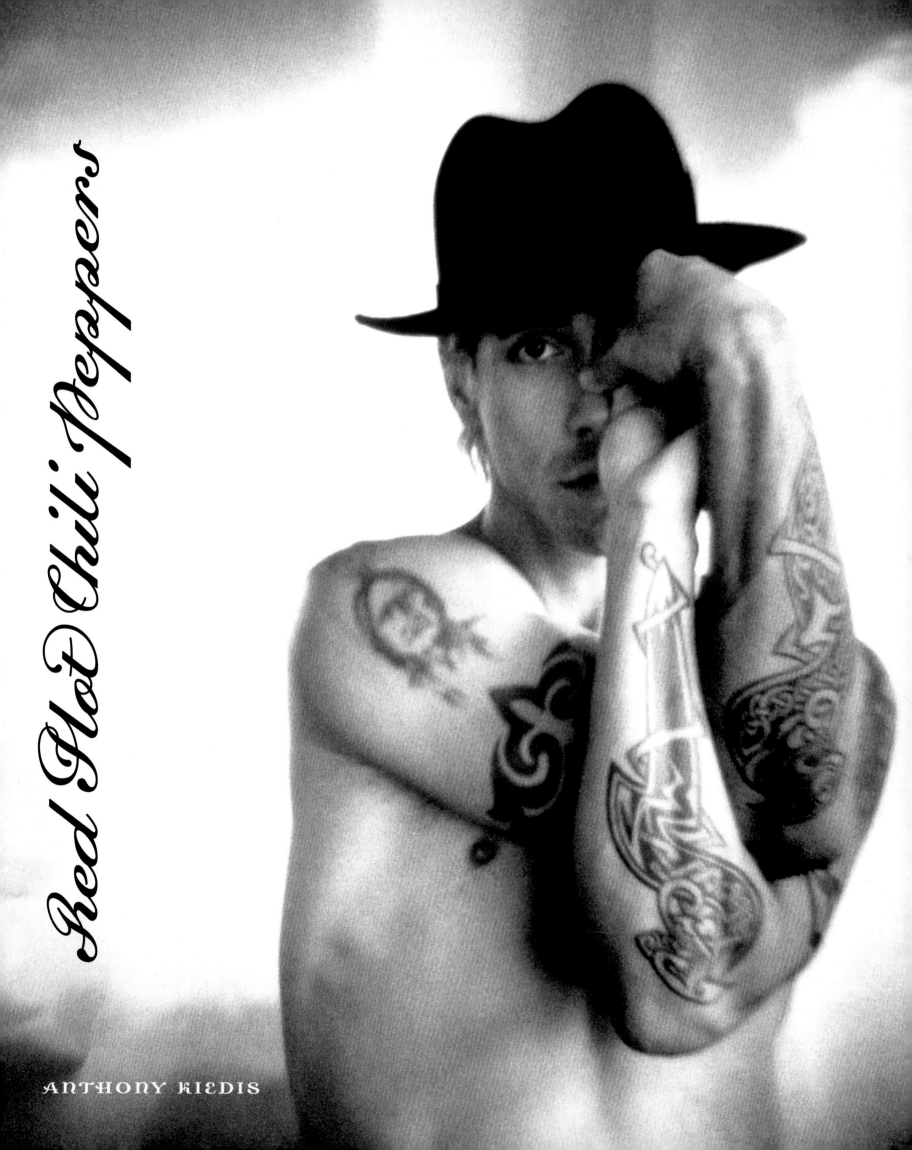

Red Hot Chili Peppers

ANTHONY KIEDIS

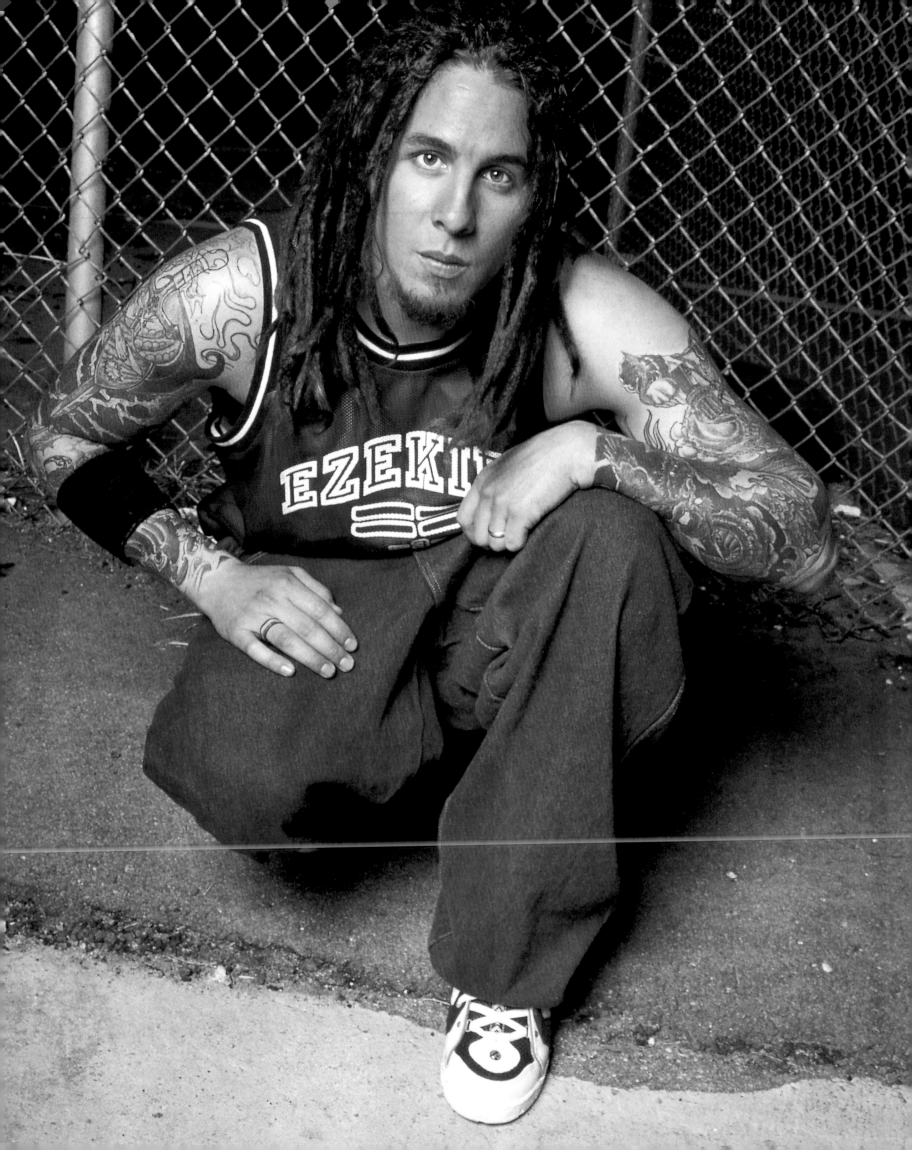

P.O.D.

Wuv

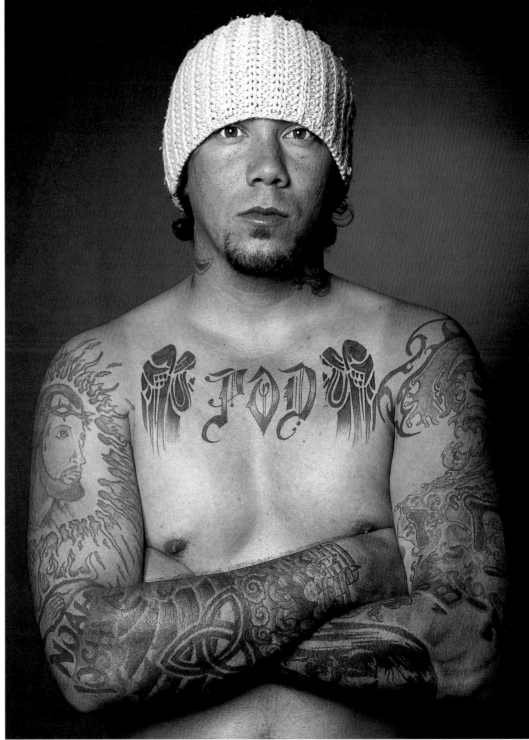

When my friend Mike first started tatting me, he was just learning. We were roommates. He used to tattoo out of our bedroom and make his own machines. Now he's top-notch. Most of the stuff on me is crap, and now that he's good he's fixing it up.

—Sonny Sandoval

METHOD MAN
of WU-TANG CLAN

Brian Setzer

OF THE BRIAN SETZER ORCHESTRA

My dad said: "Never get a tattoo where a judge can see it."

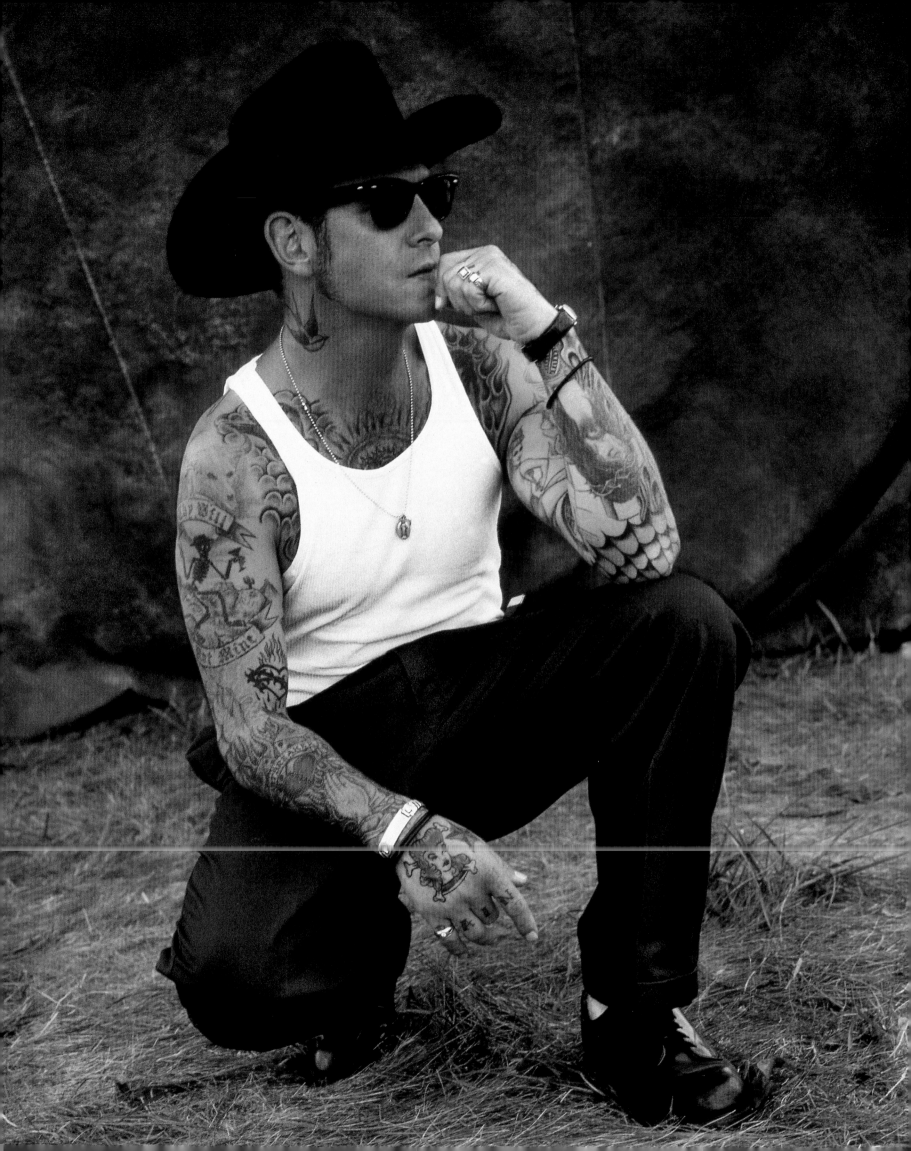

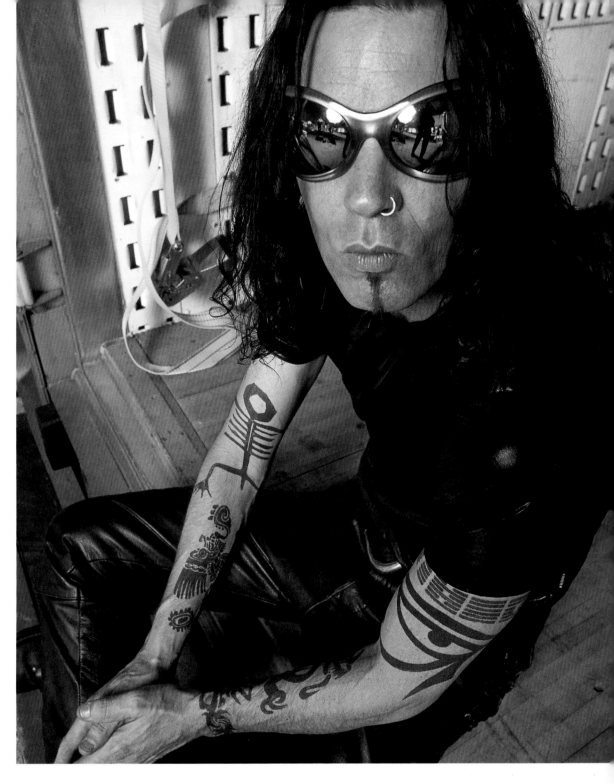

Jizzy Pearl
of L.A. GUNS

I got tattoos for purely antisocial reasons, and now people do it for social acceptance. I miss the individualism.

—Mike Ness
of SOCIAL DISTORTION

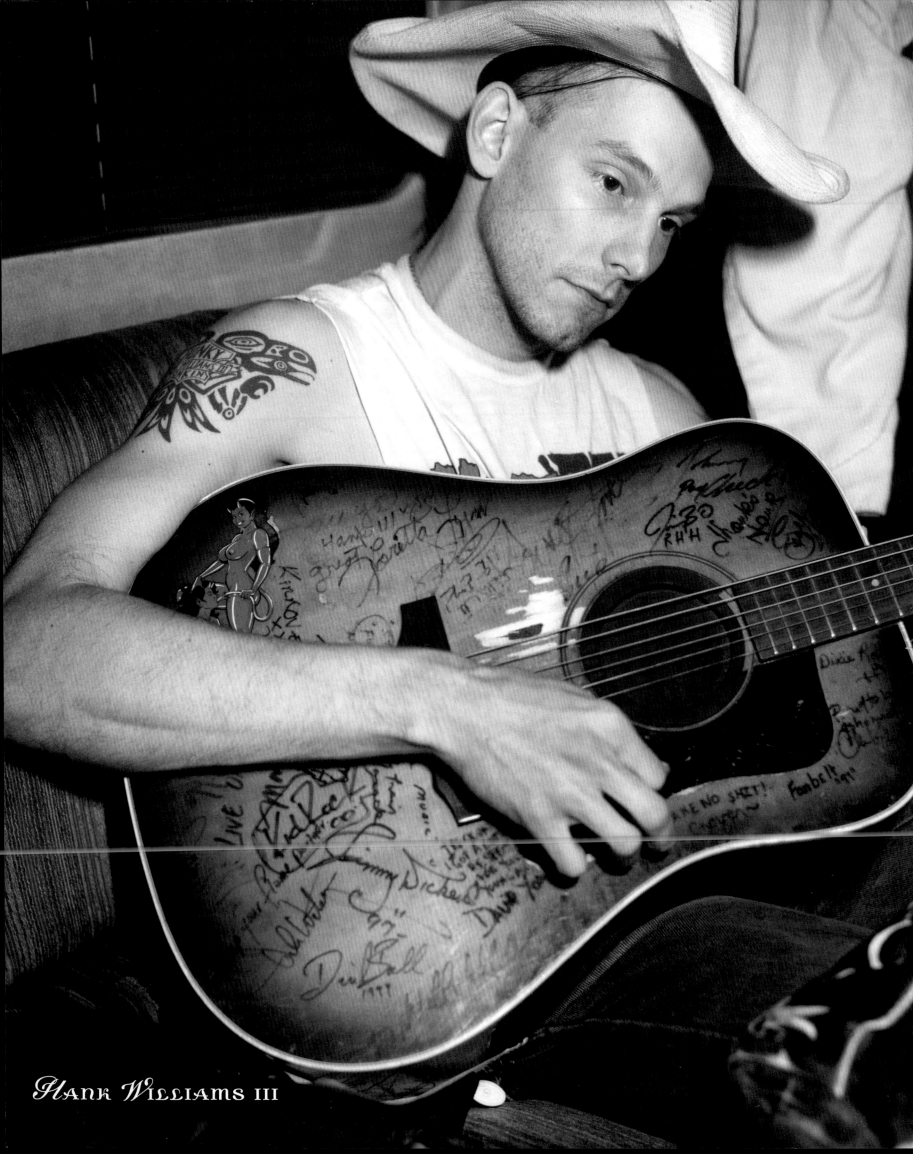

Hank Williams III

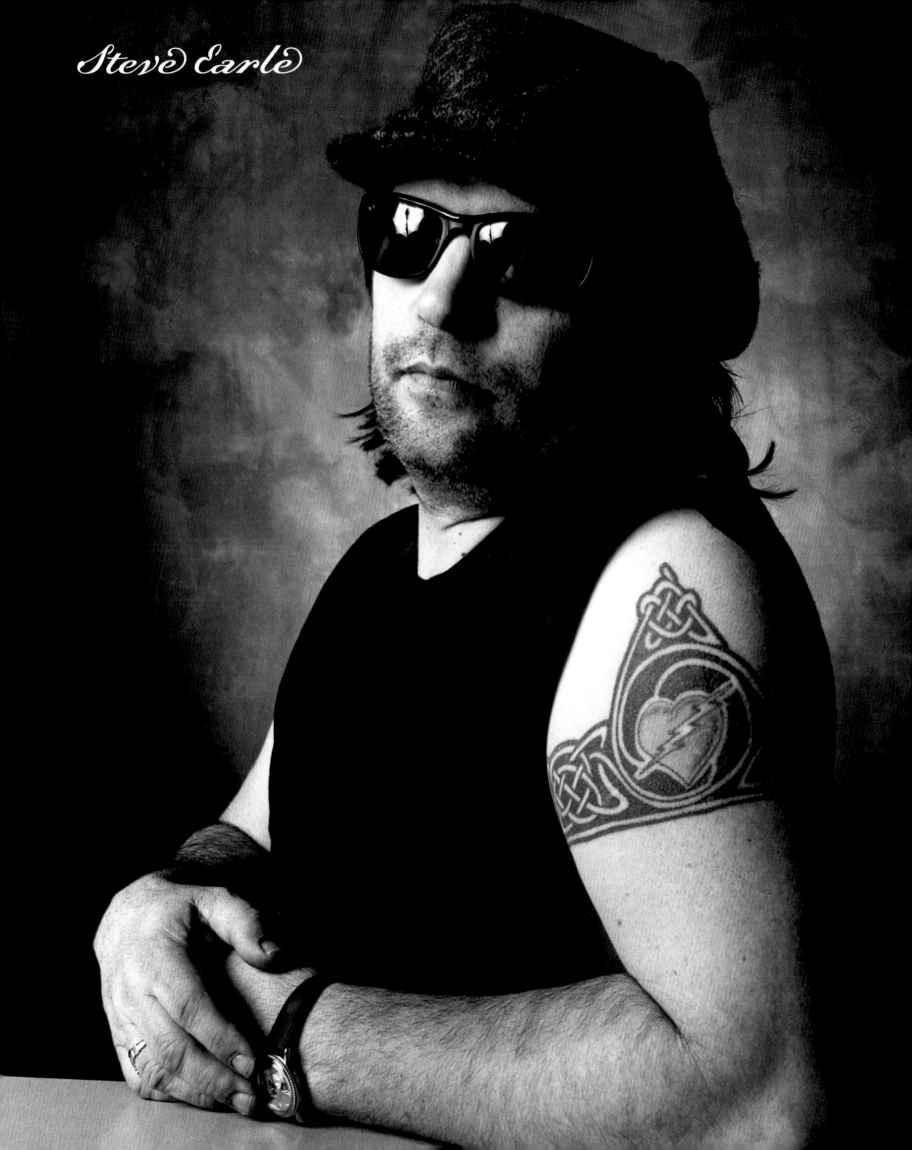

Steve Earle

Tattoos aren't meant for everybody, and they're too goddamn good for some people.

—LYLE TUTTLE

LEGENDARY TATTOO ARTIST
of the SIXTIES

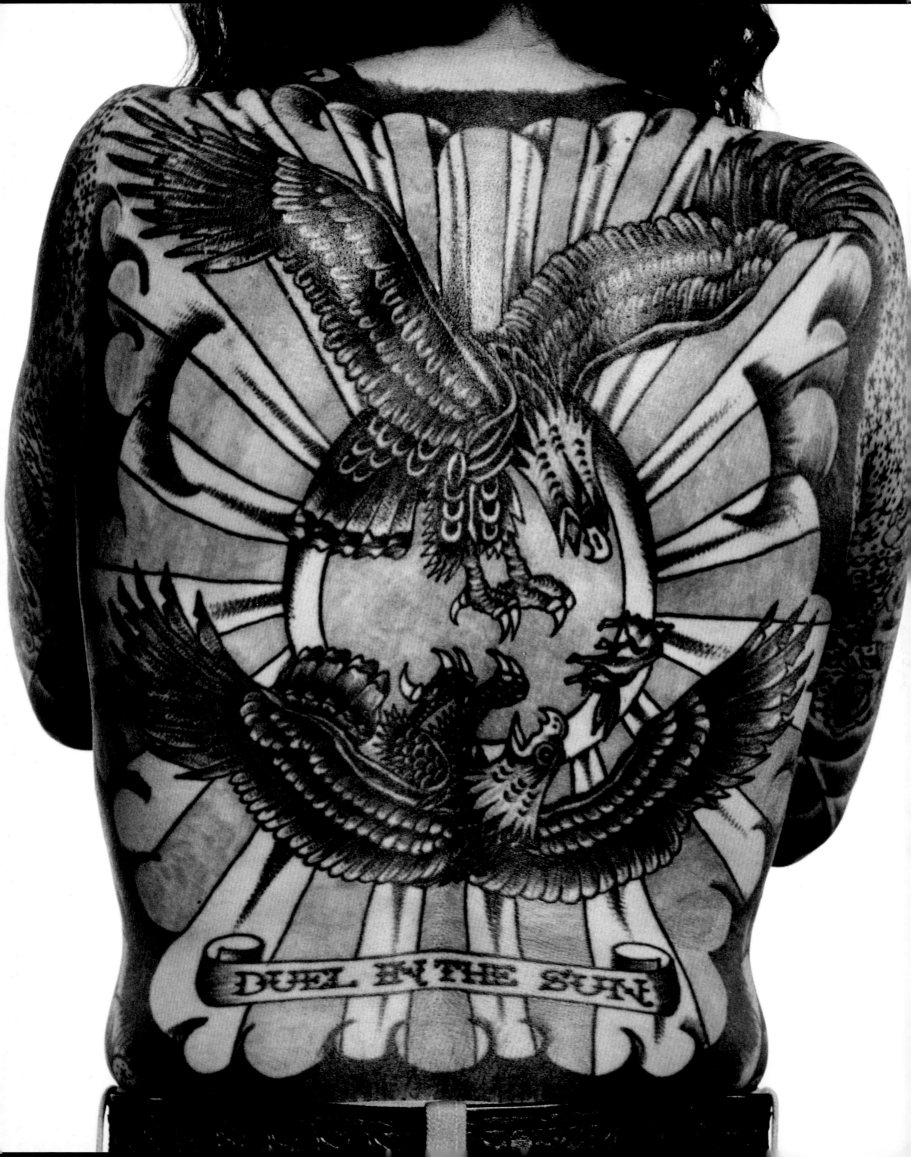

Photo Credits

Front cover: Drew Barrymore
by Mark Seliger/Corbis-Outline, 1997

David Ritz with daughters
Alison and Jessica
by Nicola Goode, 2002

Kerry King of Slayer
by Gene Ambo, 2002

Shaggy 2 Dope of Insane Clown Posse
by Robert Alford, 2001

Ozzy and Sharon Osbourne
by Mark Seliger/Corbis-Outline, 2000

Pamela Anderson
by Mark Abrahams, 2001

Busta Rhymes
by Dah Len, 2000

Eve *by Danny Clinch, 2000*

Tommy Lee of Methods of Mayhem
by David LaChapelle/Corbis-Outline, 2000

Blink-182
by Mark Seliger/Corbis-Outline, 2000

Fred Durst of Limp Bizkit
by Jeffrey Newbury/Corbis-Outline, 1999

Kid Rock
by Jamie Beeden/Katz/CPi, 2001

Treach of Naughty by Nature
by Ben Watts, 1987

P. Diddy
by Dana Lixenberg, 1996

Ja Rule
by Sacha Waldman, 2002

Eminem
by Jonathan Mannion, 2000

Tairrie B. of My Ruin
by Markus Cuff, 2001

Jacoby Shaddix of Papa Roach
by Gene Kirkland, 2002

Tricky *by Jonathan Mannion, 2000*

k.d. lang
by David LaChapelle/Corbis-Outline, 1995

Michael Stipe of R.E.M.
by Todd Oldham, 1998

Prodigy of Mobb Deep
by Mark Mann, 2001

Sisqó
by Nick Baratta/CPi, 2000

Mark McGrath
of Sugar Ray
by Mark Seliger/Corbis-Outline, 1999

Dryden Mitchell
of Alien Ant Farm
by Lisa Johnson, 2001

Dixie Chicks
by Ed Rode, 1999

Lenny Kravitz
by Stephanie Pfriender, 2001

Josh Todd of Buckcherry
by Gene Ambo, 2001

D'Angelo *by Ben Watts, 2000*

Meshell Ndegéocello
by Mark Seliger/Corbis-Outline, 1996

Brandon Boyd of Incubus
by John Huba/A+C Anthology, 2000

Ani DiFranco
by Rafael Fuchs/Corbis-Outline, 1995

Joan Jett
by Cathrine Wessel, 1997

Moby
by Kevin Westenberg, 2000

Henry Rollins
by Albert Watson, 1996

Björk
by Han Lee de Boer/Katz/CPi, 1994

Melissa Etheridge
by Dan Winters, 2001

Perry Farrell
by RCWW/Corbis-Outline, 1997

Drew Barrymore
by Mark Seliger/Corbis-Outline, 1995

Rose McGowan
by Dorothy Low/Corbis-Outline, 1997

Courtney Love
by Ellen von Unwerth/A+C Anthology, 1997

Marilyn Manson
by David LaChapelle/Corbis-Outline, 1998

Nikki Sixx of Mötley Crüe
by Markus Cuff, 1997

Evan Seinfeld
of Biohazard
by Markus Cuff, 1999

Fieldy of Korn
by Markus Cuff, 1998

Cypress Hill
by Kevin Westenberg, 2000

DMX *by Albert Watson, 2000*

Slash
by Mark Seliger/Corbis-Outline, 1990

AXL ROSE
by Herb Ritts, 1991

ROB ZOMBIE
by Annamaria DiSanto, 1998

JANIS JOPLIN
by David Gahr, 1970

TOM WAITS
by Annie Leibovitz/Contact Press Images, 2001

PAUL BOOTH
by Emily Shur, 2002

BACKSTREET BOYS
by Mark Seliger/Corbis-Outline, 2000

JUSTIN TIMBERLAKE OF 'NSYNC
by Mark Liddell/Icon International, 2001

JOHNNY RZEZNIK
OF GOO GOO DOLLS
by Danny Clinch, 1999

JON BON JOVI OF BON JOVI
by Anton Corbijn, 1992

DAVE GROHL OF FOO FIGHTERS
by Danny Clinch, 1999

TUPAC SHAKUR
by Danny Clinch, 1993

CARSON DALY
by Mark Seliger/Corbis-Outline, 2001

8 BALL OF 8 BALL & MJG
by Carl Posey, 1998

PSYCHO LES OF THE BEATNUTS
by Estevan Oriol, 2000

OUTKAST
by T. Hopkins, 2000

REVEREND HORTON HEAT
by Mark Seliger/Corbis-Outline, 1994

THEO KORGAN OF LUNACHICKS
by Mark Alesky, 2001

A.JAY POPOFF OF LIT
by Martin Schoeller, 1999

ROBBIE WILLIAMS
by James Dimmock, 2000

STEVEN TYLER OF AEROSMITH
by Billie Paulette Perry, 2002

JOE PERRY OF AEROSMITH
by Billie Paulette Perry, 2002

SCOTT WEILAND OF STONE TEMPLE PILOTS
by Mark Seliger/Corbis-Outline, 2000

PINK
by Bernd Eberle/Vanit.de/CPi, 2000

JOHN LEGUIZAMO
by Yariv Milchan/CPi, 2001

DAVE NAVARRO
by Mark Seliger/Corbis-Outline, 1997

FAITH EVANS
by Dah Len, 2000

BEN HARPER
by Anthony Mandler, 2001

EVERCLEAR
by Stephen Stickler, 2000

NEPTUNES
by Jonathan Mannion, 2002

MAXWELL
by Martyn Gallina-Jones, 1996

NELLY
by Anthony Mandler/Corbis-Outline, 2001

TROUBLE OF CRAZY TOWN
by Markus Cuff, 2001

SHIFTY SHELLSHOCK
OF CRAZY TOWN
by Nathaniel Welch, 2001

MARY J. BLIGE
by Mark Seliger/Corbis-Outline, 2001

MARK WAHLBERG
by Mark Seliger/Corbis-Outline, 1997

MASTER P
by Davis Fa or/Corbis-Outline, 1998

DAVID BLAINE
by Yariv Milchan/CPi, 2000

FLEA OF RED HOT CHILI PEPPERS
by Martin Schoeller, 2000

ANTHONY KIEDIS OF RED HOT CHILI PEPPERS
by Danny Clinch/Corbis-Outline, 1999

SONNY SANDOVAL OF P.O.D.
by Annamaria DiSanto, 2000

WUV OF P.O.D.
by Markus Cuff, 2001

METHOD MAN OF WU-TANG CLAN
by Estevan Oriol, 2000

BRIAN SETZER
OF THE BRIAN SETZER ORCHESTRA
by Len Irish, 1998

MIKE NESS OF SOCIAL DISTORTION
by Len Irish/Corbis-Outline, 1999

JIZZY PEARL OF L.A. GUNS
by Annamaria DiSanto, 1999

HANK WILLIAMS III
by Ben Watts, 2001

STEVE EARLE
*by Jim McGuire/
McGuire@NashvillePortraits.com, 1997*

LYLE TUTTLE
by Albert Watson, 1972

SLIPKNOT SCOTT
by Karen Hoyt, 2001

MADONNA ON CRACK
by David LaChapelle/A+C Anthology, 1998

ENDPAPERS: TOM RENSHAW *(tattoo artist &
photographer)* – Louis Armstrong, Drew Barrymore,
Boy George, James Cagney, Young Johnny Cash,
Sean Connery, Rodney Dangerfield, James Dean,
Robert De Niro, Clint Eastwood, Jimi Hendrix
(twice), John Lennon, Bob Marley *(twice)*, Willie
Nelson, Jack Nicholson, Elvis Presley, Sylvester Stal-
lone, Stevie Ray Vaughan, John Wayne, Frank Zappa
ANIL GUPTA *(tattoo artist & photographer)* – Albert
Einstein, Four Composers, Grateful Dead *(Garcia &
skeletons)*, Bruce Lee, Abraham Lincoln, Bob
Marley and the Wailers, Jack Nicholson *(scene
from THE SHINING)*, Ozzy Osbourne *(twice)*, Al
Pacino *(with cigar)*, Frank Sinatra, Tutankhamen,
Vincent van Gogh

BACK COVER: BILLIE JOE ARMSTRONG
OF GREEN DAY
by Jay Blakesberg, 1994

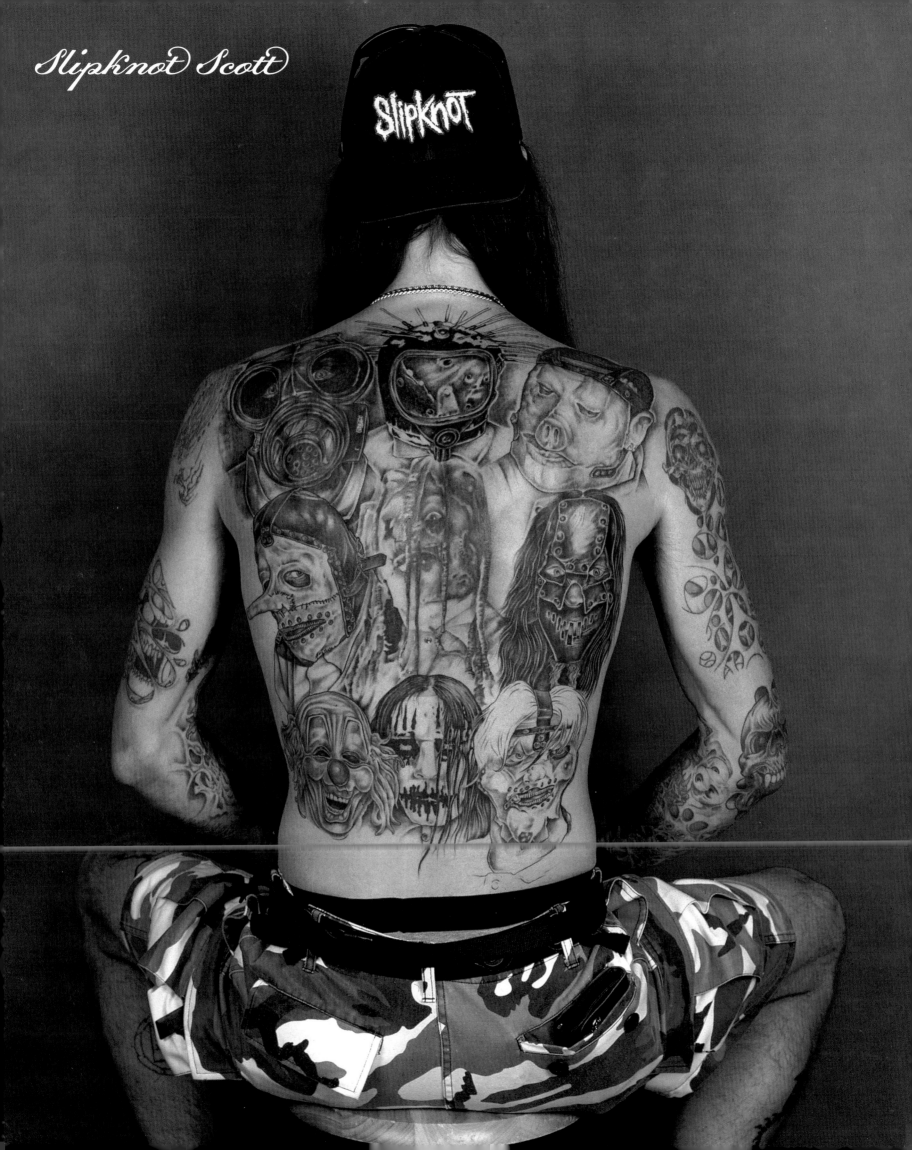

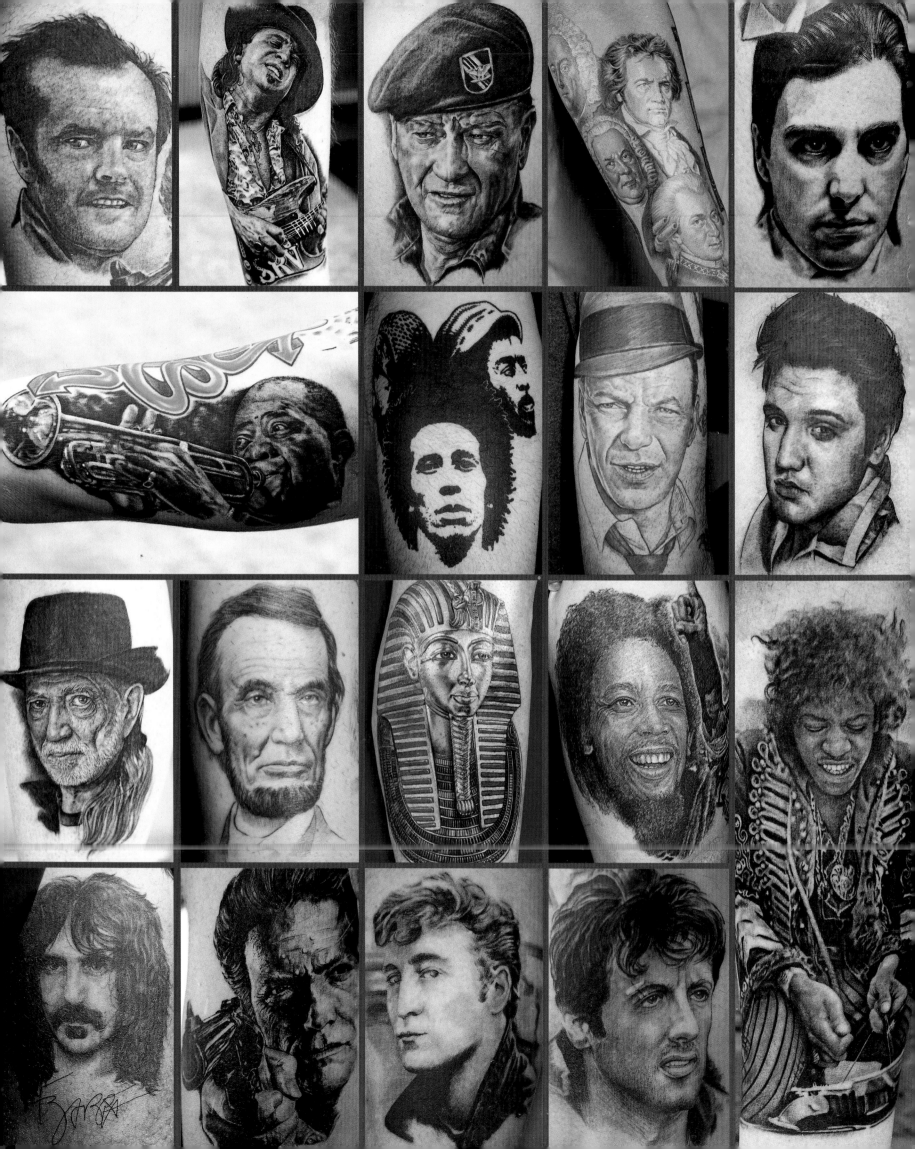